SHOOTING STARS

PRESIDENT DWIGHT D. EISENHOWER

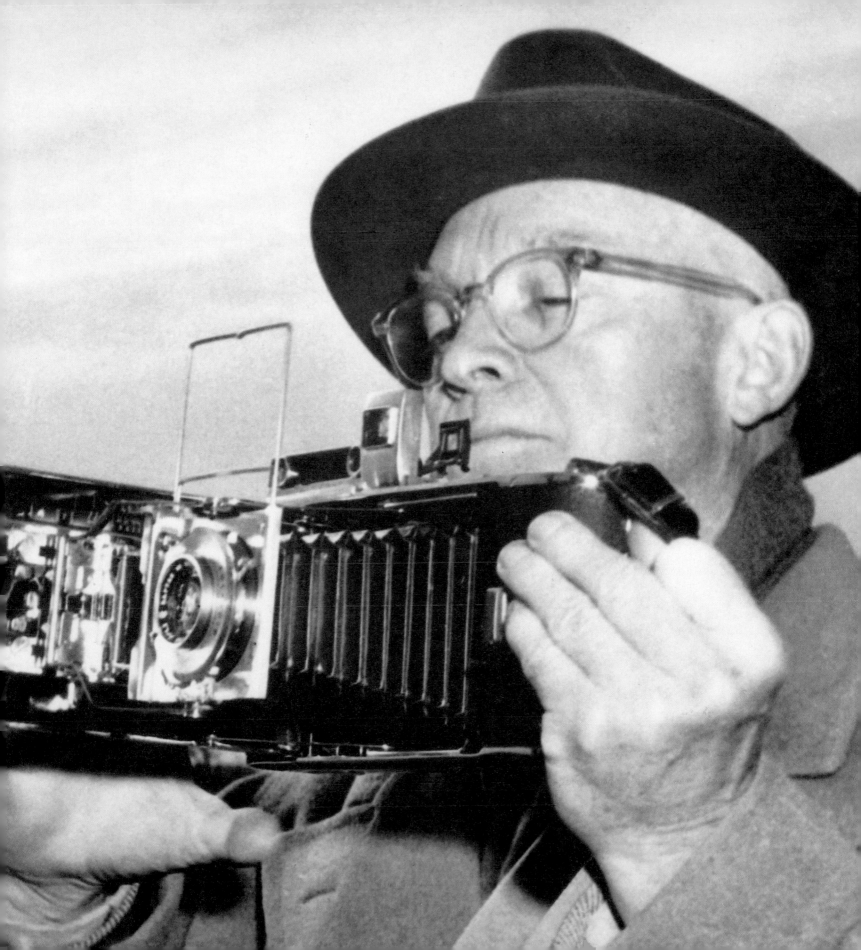

ELVIS PRESLEY

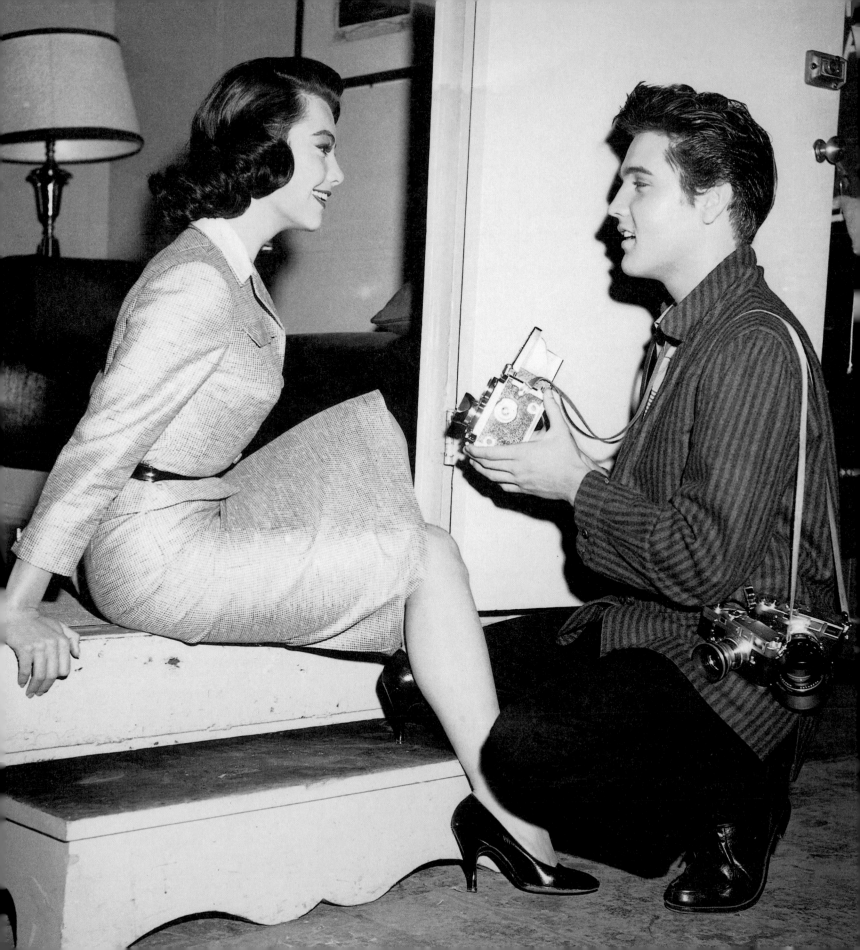

JERRY LEWIS

TONY CURTIS

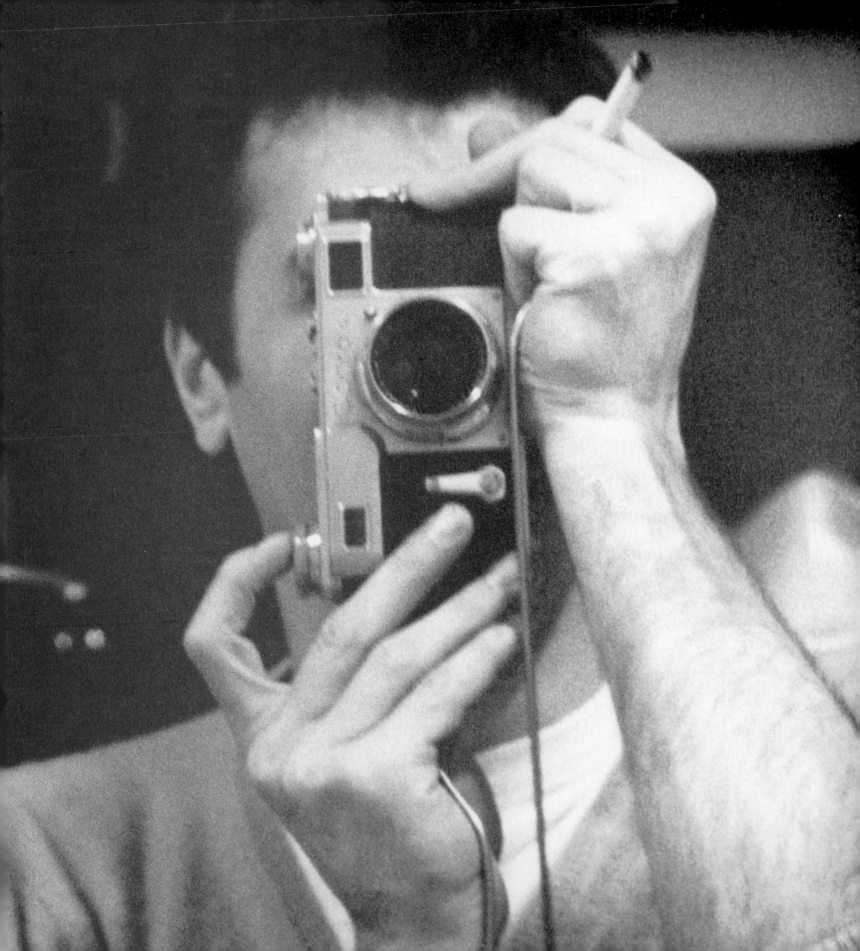

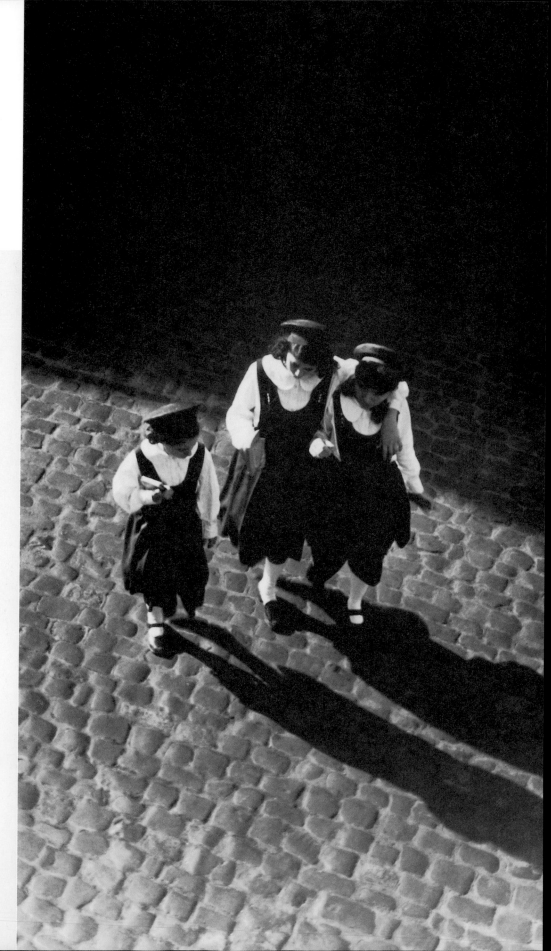

Publisher: W. Quay Hays

Editorial Director: Peter L. Hoffman

Designer: Dana Granoski

Design Concept: Robert Avellan

Production Director: Trudihope Schlomowitz

Color and Prepress Manager: Bill Castillo

Production Artist: Bill Neary

Production Assistants: Tom Archibeque, Dave Chadderdon,
Russel Lockwood

Editorial Assistance: Kristi Cardarella, Dominic Friesen,
Rachelle Gardner

For information:

General Publishing Group, Inc.
2701 Ocean Park Blvd., Suite 140
Santa Monica, CA 90405

Library of Congress Cataloging-in-Publication Data

Shooting stars : favorite photos taken by classic celebrities /
 conceived and compiled by David I. Zeitlin : restored and
 revised by Harriet Zeitlin ; introduction by Charles
 Champlin.
 p. cm.
 ISBN 1-57544-077-6 (hardcover)
 1. Photography, Artistic. 2. Celebrities--Interviews.
 3. Zeitlin, David I.--Photograph collections. I. Zeitlin, David
 I. II. Zeitlin, Harriet, 1929- .
 TR654.S5222 1998
 779'.0922--dc21 98-20444
 CIP

Printed in the USA by RR Donnelley & Sons Company

10 9 8 7 6 5 4 3 2 1

General Publishing Group

Los Angeles

Photo (right) taken by Senator Barry Goldwater

SHOOTING STARS

FAVORITE PHOTOS TAKEN BY CLASSIC CELEBRITIES

Conceived and compiled by David I. Zeitlin

Restored and revised by Harriet Zeitlin

Introduction by Charles Champlin

GENERAL PUBLISHING GROUP

LOS ANGELES

CONTENTS

Photo of Marlon Brando taken by Joshua Logan

\mathscr{D}edication

To David Zeitlin, my husband of 40 years, who conceived the idea for this book and contacted hundreds of celebrated Americans between 1956 and 1958 to compile this extraordinary collection of personal photographs. David was an exemplary photo-journalist (writer and photographer), public relations and communications director, magazine founder and editor, producer, documentary filmmaker, Marine Corps Colonel, AIDS activist, sailor, fisherman, vegetable farmer, husband, father, and human being. I regret with all my heart that he is not here for the fulfillment of the publication of *Shooting Stars* and to share in the gratification that we all feel.

— Harriet Zeitlin

Introduction

My colleague David Zeitlin in its, and our, days of glory at *Life* magazine, was by trade a reporter and writer and a very damned good one. But like almost all *Life* reporters he was also an amateur photographer (at least, and very good, too). This second skill grew out of a combination of contagious excitement, photojournalist experience working for local newspapers since the age of 12, sheer need to understand more about the conceiving and making of pictures, and a practical need to know the basics of cameras themselves.

Dave was *Life's* Hollywood correspondent for 12 years, and it was in those days that he became intrigued by the question of what the most photographed figures on earth shoot when they have a camera in their hands.

As projects will, his grew to become a passion—a pursuit of pictures by stars that was as compelling as the quest for the Lost Dutchman mine or the lost chord. He carried on a voluminous correspondence with celebrities as various as Harry Truman in retirement and Grace Kelly in Monaco, and what he heard back was often as charming and revealing as the snapshots themselves.

Sadly enough, Dave left us before the pictures he had assembled could be published in book form. But his treasure trove has been lovingly collated by Harriet Zeitlin. And what is touching and fascinating to me, and I suspect to all of us who knew Dave, is how much Dave's spirit—enthusiastic, amused, determined, kindly—shines through these pages. In their responses, the stars he knew and worked with reveal their fondness for him.

His passion has resulted in a unique book, rich with glimpses of their world as captured by those whom the world looked at so often. Thank you, Dave.

— *Charles Champlin*
Los Angeles

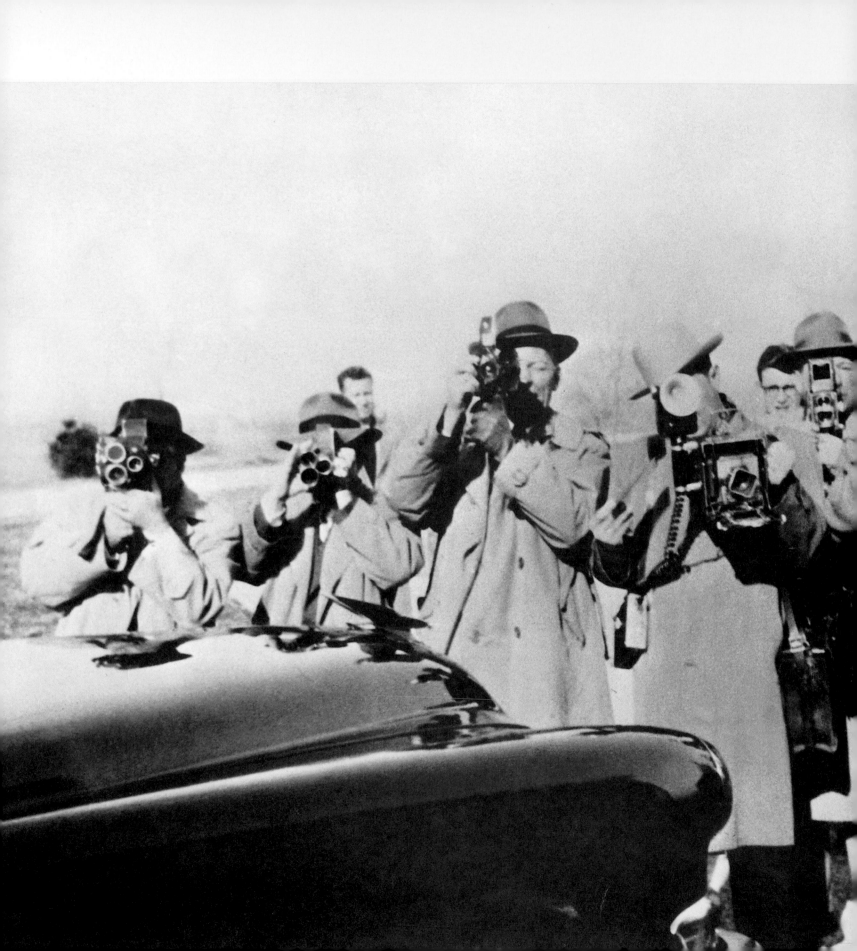

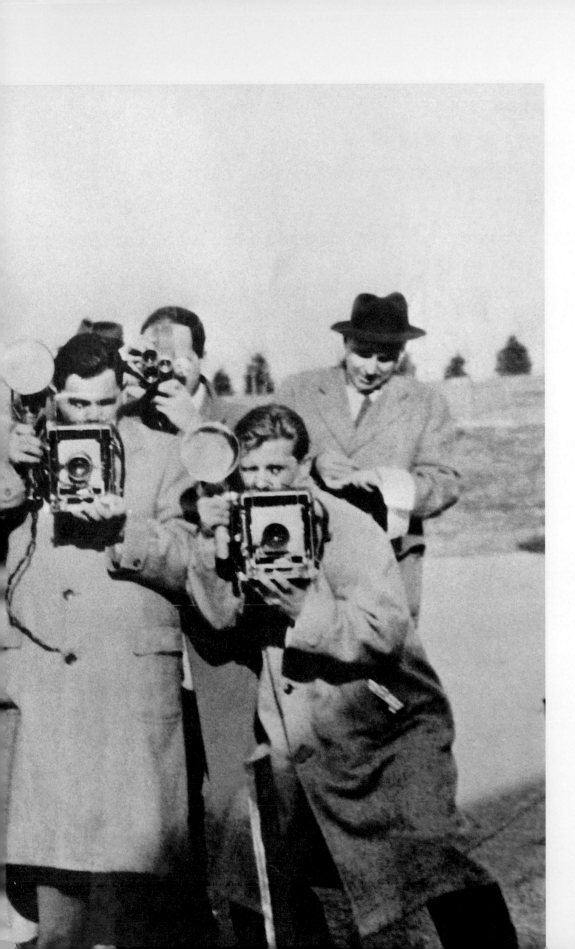

DWIGHT D. EISENHOWER

The irresistible impulse to turn the tables resulted in this picture taken by President Eisenhower. Back in January 1955, the president posed for the White House photographers who had followed him to his farm at Gettysburg, and after they had taken their shots, he merely said, "Now, let me reverse the tables and take your picture." Eisenhower took the photograph with a Polaroid Land Camera. A man of many interests, the President would on occasion combine two of his hobbies—photography and painting. Sometimes he'd shoot with a Stereo camera and paint in oils from photographs he had taken.

EDDIE CANTOR

In our family, the eyes have it—as witness these snapshots of my grandchildren, Amanda and Brian Gari. We're all crazy about babies in this family. When Amanda was born you'd think none of us had ever seen a baby before—such a little pussycat. We manage to entice these youngsters to California periodically but they live in New York with their poppa and momma (artist Bob Gari and our daughter, Janet). However, if you take pictures of the people you love, you keep them with you. So I take pictures. The end result doubles in brass. You always have a calling card. You can always show off to your friends. You can always top their stories. What more can you ask of a one-focus Brownie?

This is a picture of my daughter Candy in her "bubble bathrobe." I took it with my four-by-five speed graphic and used a flash. I guess I am a photographer because the camera and the darkroom comprise, for me anyway, the answer for an incurable tinkerer.

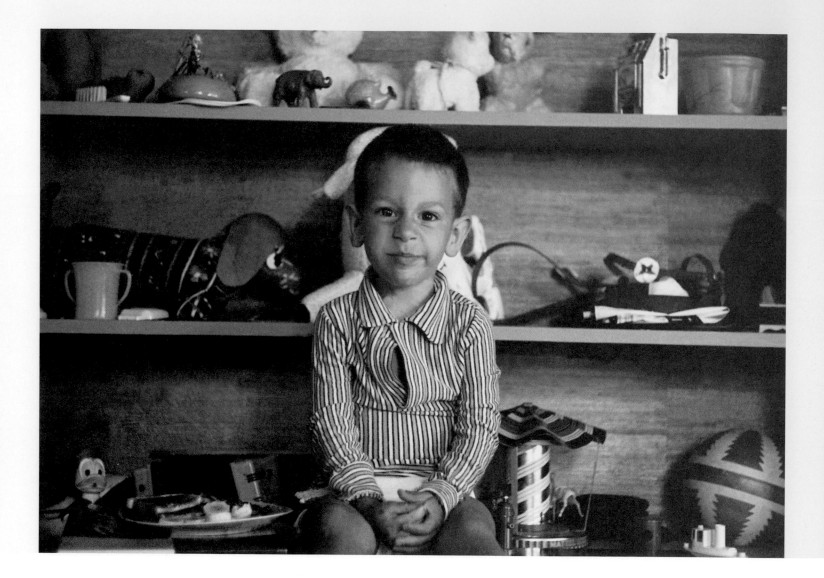

JOSE FERRER

When I am working at my profession, I find it impossible to do anything else. When I am not working, however, I have found a number of activities which provide me with amusement and relaxation, however strenuously pursued—playing tennis, fox hunting (Elsa Maxwell notwithstanding), playing the piano, driving a car, traveling, staying at home, sleeping, reading, drinking, playing chess, painting, and of course, taking photographs. I take pictures for one reason only: I happen to have

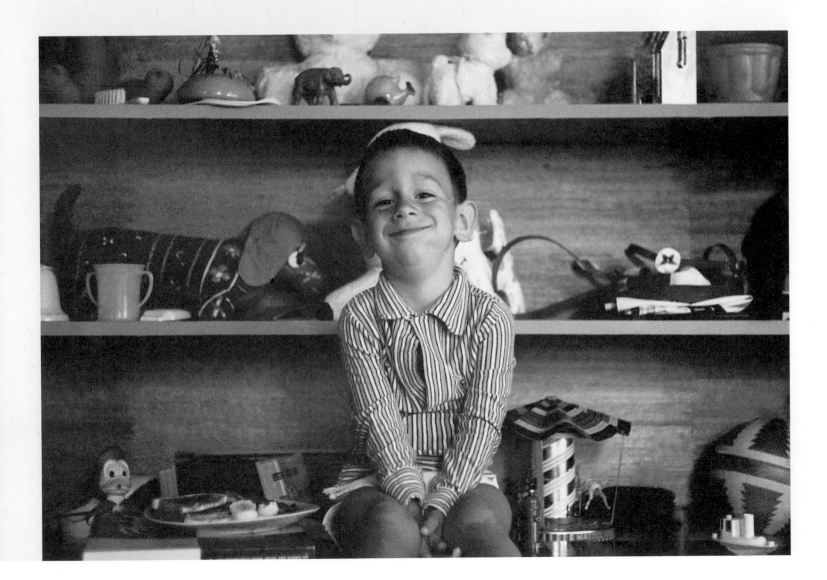

my camera with me at an event I would like to record. The birthday party of one of my children, for instance, represents a dreary photographic duty which later on I am glad I carried out. The pair of Miguel José was taken in the children's playroom in our house in Beverly Hills. This playroom used to be my study but the inner expansion of a growing family crowded me out. I posed him in front of a lot of my former bookshelves, now stacked with his toys.

JOSE FERRER

Bullfights and prizefights I never attend without a camera. The following spread shows Tony Curtis and Janet Leigh before and after the fight.

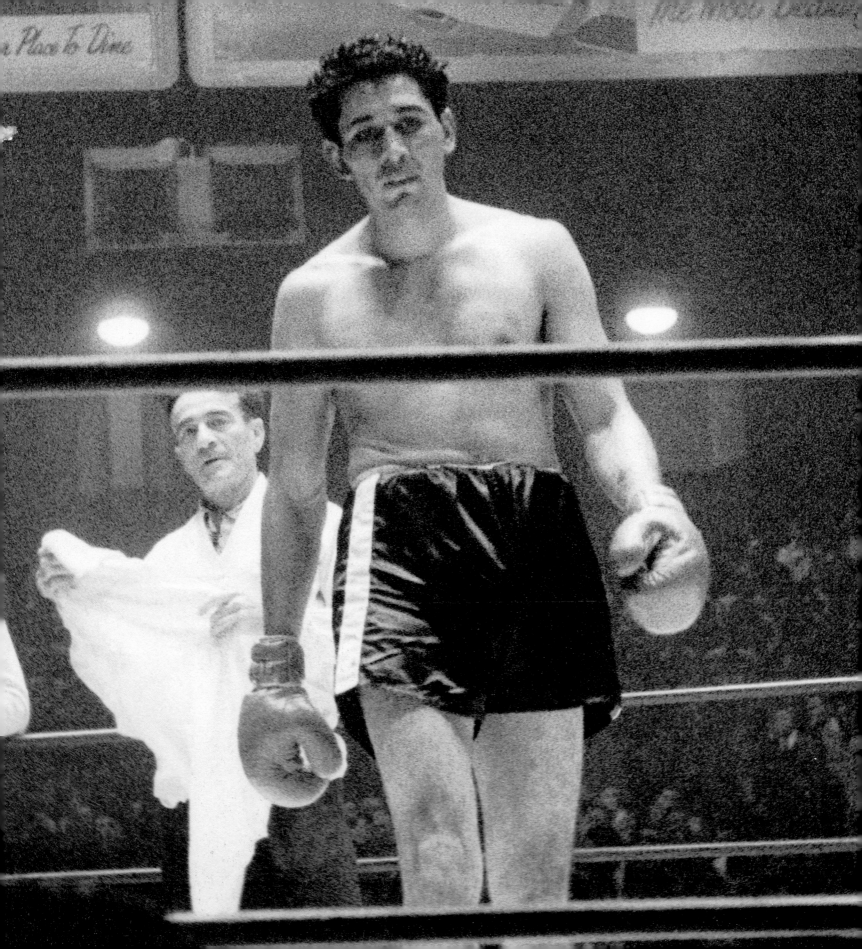

Looking for victory.

Staring at defeat.

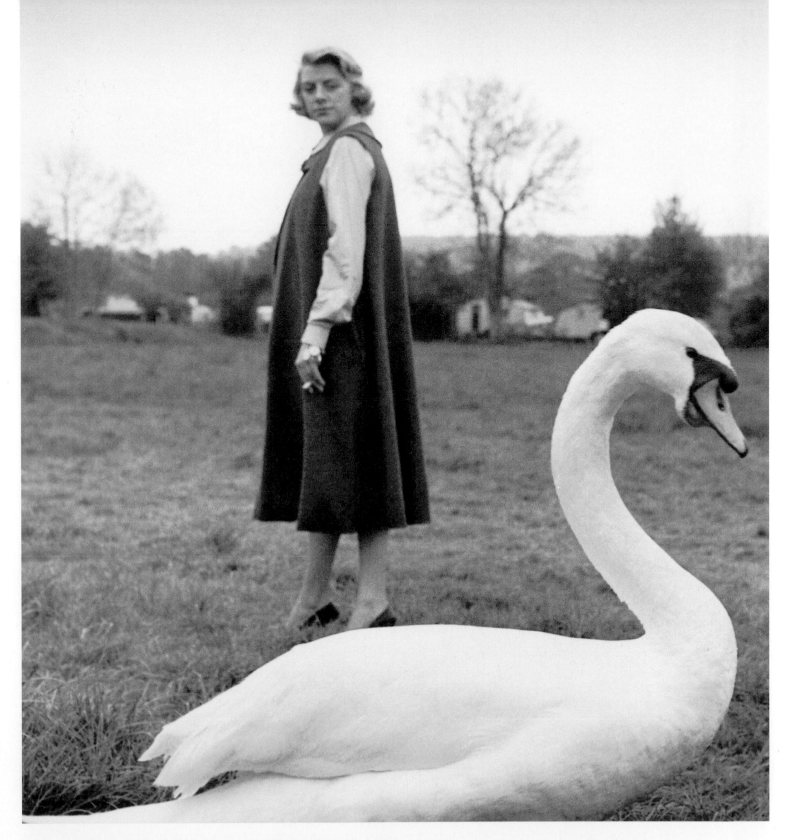

Rosemary (enceinte [sic] with our third, Gabriel Vicente) and the
swan formed both an amusing scene and an interesting abstract.

BURT LANCASTER

A short time ago, I realized that the only phase of my business I had never taken any interest in was photography. To me acting—the playing of a scene—was always of paramount importance. I had learned something about lenses and composed several shots through the viewer when directing *The Kentuckian* in 1954, but I had never made a real study of photography, still or movie. As I contemplated my future plans, which include directing some films, I decided I had better make it my business to learn photography. I bought a Rollieflex and a Bolex movie camera. These pictures, which I took of my children on an expedition to Disneyland, are really the first ones I took with a serious purpose. I think they came out well, too, but I don't take any of the credit for the results. I give it all to the Camera. Of course, my interest in photography was also generated by the desire to have pictures of the kids. Not only for Norma and me, but for them as well, especially in later years. When I took these the kids could not have cared less, an attitude that seems to be clearly demonstrated in most of the shots. But later on the interest in photography spread so I had to buy them all Brownies. Now all are shooting pictures.

There are a lot of things one comes across in trips around the world, things you run across that you can't describe adequately. Pictures can describe them for you. They help to get the message across better. I carry cameras with me on all my trips, but I'm so wrapped up in my work, I don't shoot nearly as much as I'd like. I've lost a lot of good things I could have done because my cameras were packed in my bags and not hanging round my neck. I took the shot on the following pages in Australia, on a short stopover at the airport at Brisbane on the way to Melbourne. The crowd of people was taking pictures of me and I decided to take some pictures of them. "Let me take a picture of you for a change," I said, and I shot this with my Argus C3.

I took the picture below a few years ago when I was working at the Cal-Veda Lodge at Lake Tahoe, and we had a cottage on the lake for the summer. The little girl is my younger daughter Natalie. We call her "Sweetie." She was three when I took this, and that summer at Tahoe was her first exposure to the water. She liked it and waddled at first. Now she's eight and an expert swimmer.

This summer we are going to Europe for a five-week vacation. I'll take all my cameras—the Bolex, the Rollieflex, the Argus, and my Minox. I'll travel purely as a tourist and won't have any professional responsibility. I'll be ready this trip: my cameras are going to be handy all the time, and I'm going to shoot every single thing that appeals.

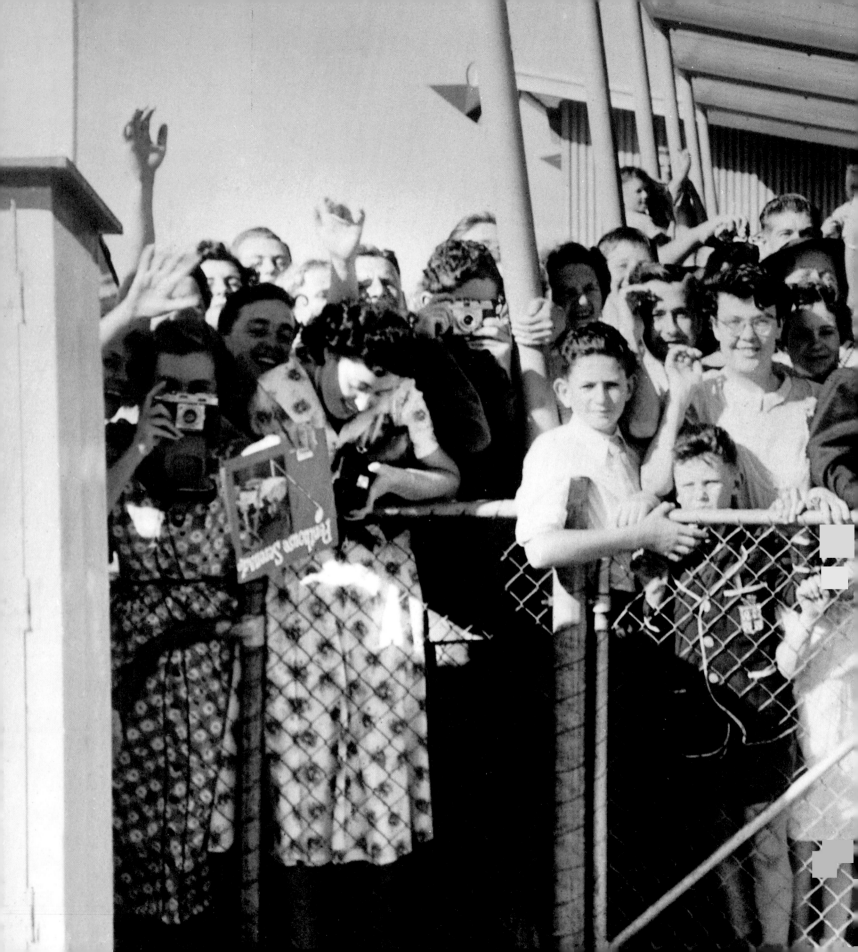

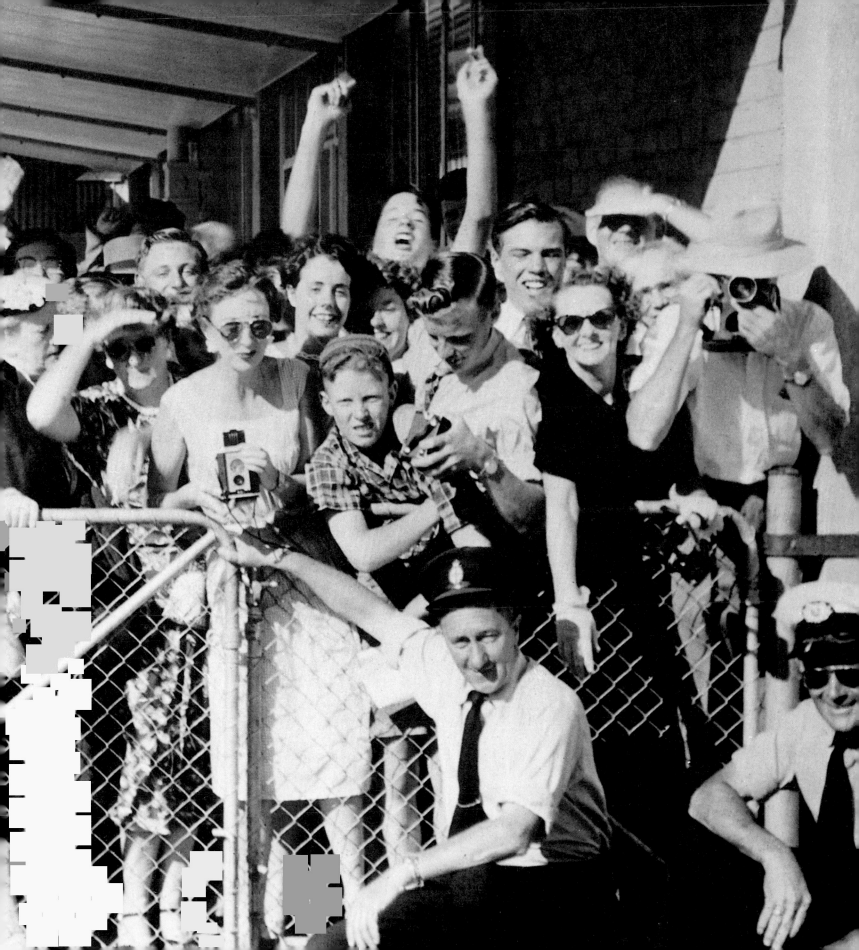

DEAN MARTIN

I caught the camera bug several years ago from my former partner, Jerry Lewis. I even went out and bought a very expensive Leica. I used it to shoot these pictures of Jerry when he was made up as a clown while we were filming *Three Ring Circus* with the Clyde Beatty Circus in Phoenix, Arizona. I like the way these shots came out, but must admit I spend a lot more time these days shooting golf than I do shooting pictures with that Leica.

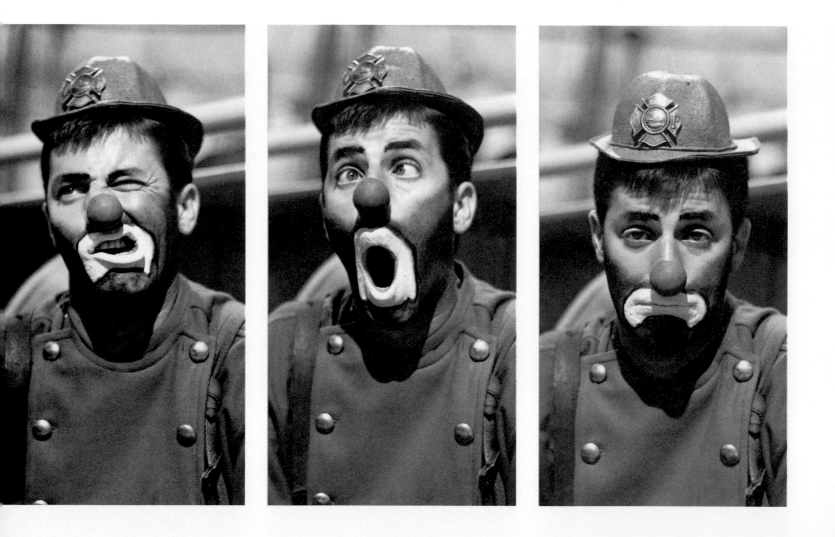

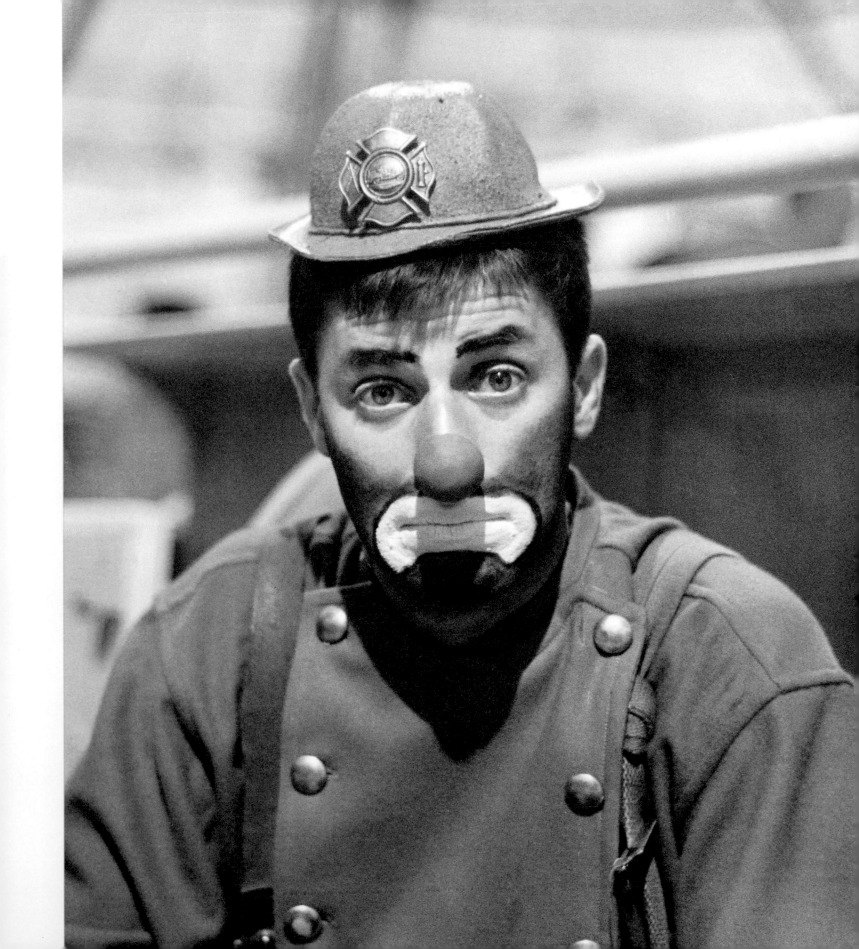

ELVIS PRESLEY

I took these pictures for kicks while making *Jailhouse Rock* at MGM. The set photographer, Kenny Bell, was showing me his cameras, and I became interested and asked him to let me make a few shots every now and then. Jennifer Holden, the girl swinging the bat and also holding the poodle, and Linda Williams were both in *Jailhouse Rock* and were kind enough to pose. All in all, I think the pictures turned out pretty good. Of course, having such pretty subjects had a lot to do with it. And I did discover there is a lot to be learned about making good pictures.

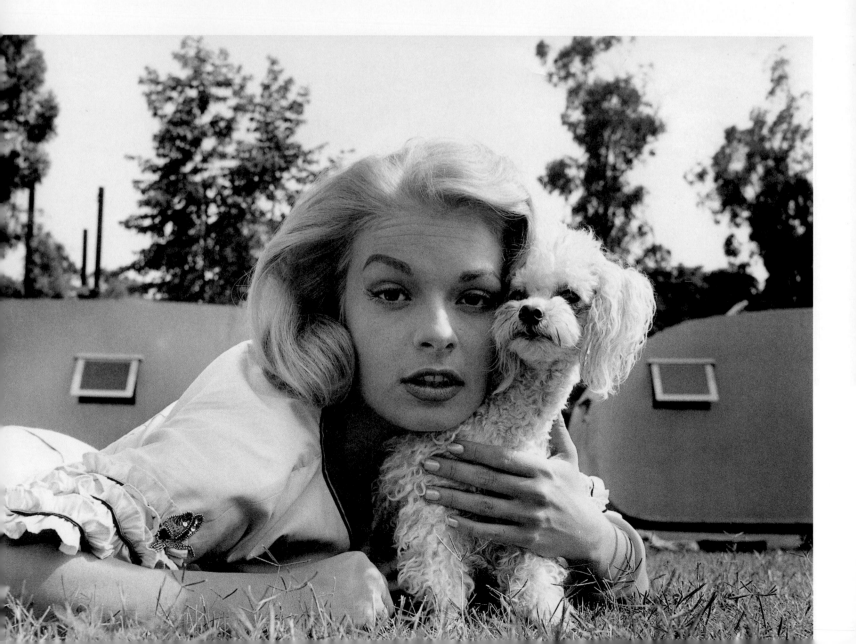

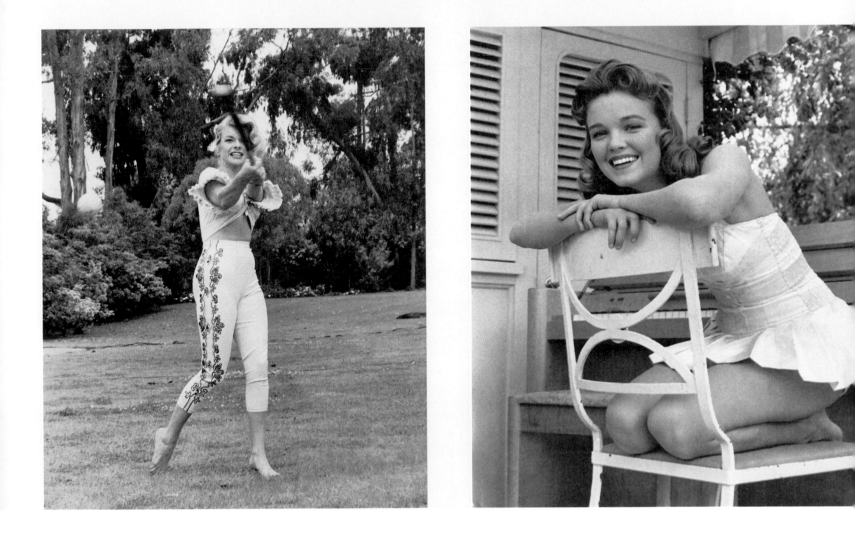

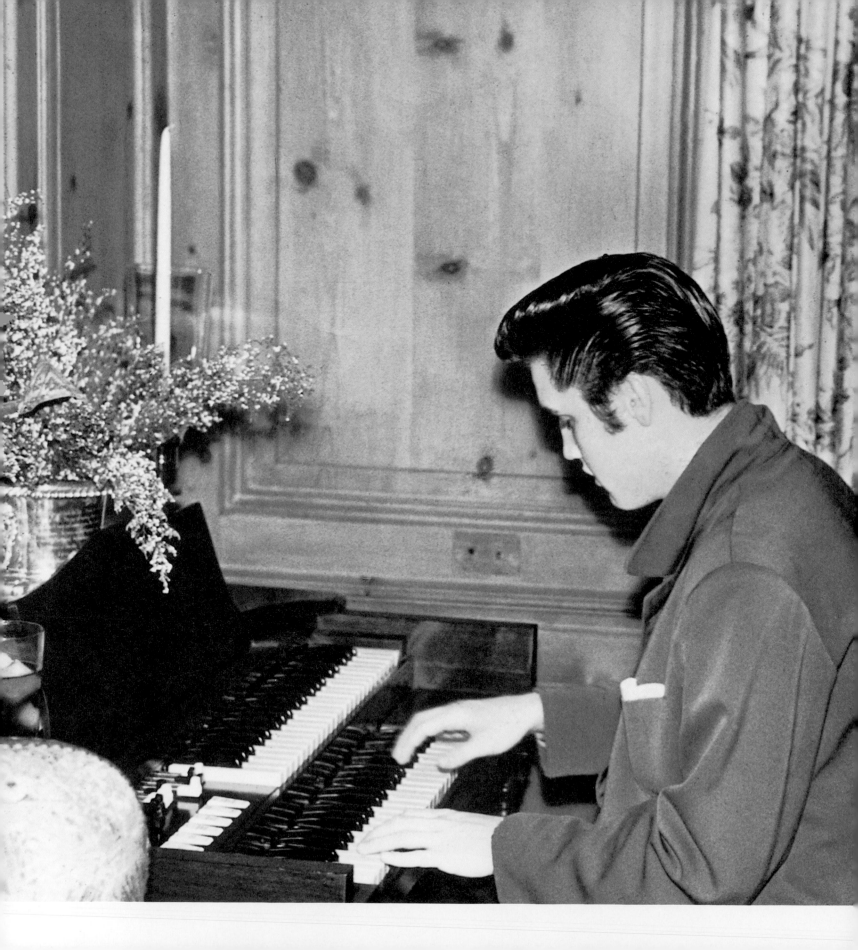

I find taking pictures the most relaxing therapy I know. I am never without a camera. I've learned through the years to always have at least one within reach at all times—whether at home or out. Having a camera handy also gives me added incentive to shoot. And when I do shoot, which is continuously, I believe in taking several shots of whatever subject I choose, for in photography there is certainly strength in numbers, and if you shoot enough, one shot must certainly turn out satisfactorily.

I took the picture of Elvis Presley when he came to our house to visit with our son, Richard. He sat at our piano and gave an impromptu performance, singing all the songs he helped make famous. He spent at least two hours visiting with us. We found him a shy, gracious, and charming person. He made a very interesting subject for the camera as he dresses colorfully and was a good model for a photographer. I used my Rollieflex; the exposure was 5.6 with a 5 bulb at 50.

CARY GRANT

I am not really a camera fiend, but one day as
Deborah Kerr and Ken Darby of 20th Century Fox
were working out a score at the studio, I became sud-
denly consumed with the passion to photograph
them. I think I was moved by the mood of the scene,
by the intense concentration, and the wondrous
expression of Deborah's face. I practically grabbed a
Rollieflex out of the hands of a studio still man and
made this picture. I am delighted with it. Everything I
saw at that moment is here forever.

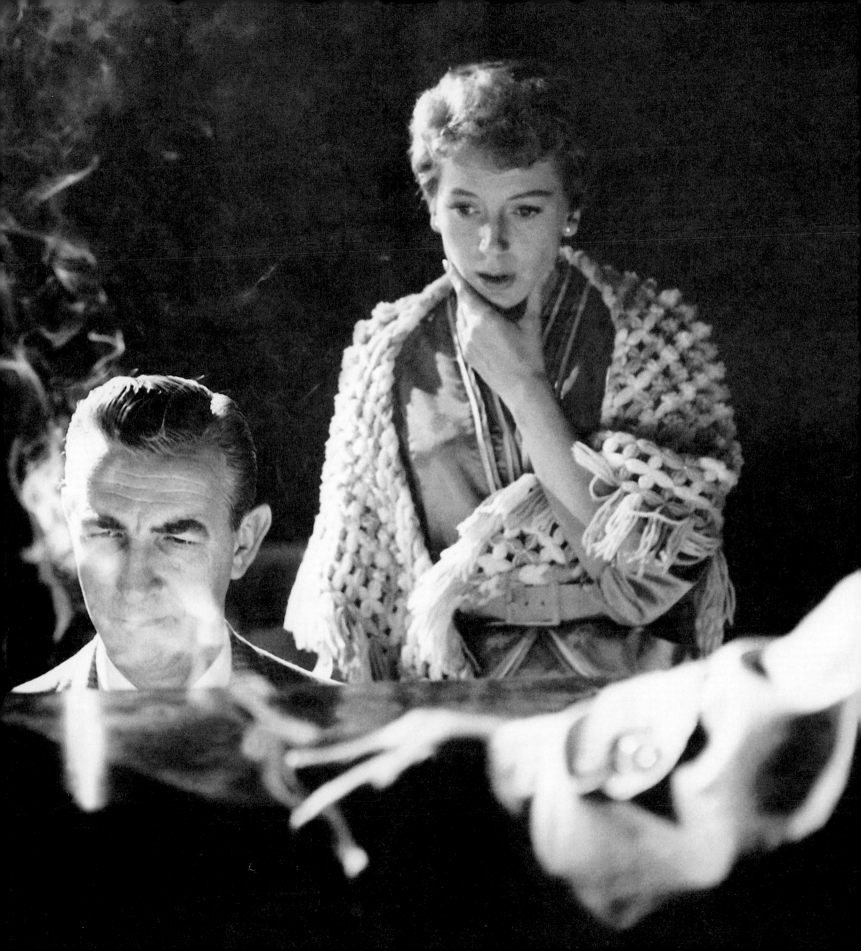

TONY CURTIS

I took the picture above in a little restaurant in Portofino, Italy. I had stopped for lunch, and the girls recognized me because one of them had a film magazine. This picture is a favorite of mine for many reasons: I like the idea of getting an interior, an exterior, and a background into one shot. And I love the archaicness, the old-fashioned feeling of the boat in the foreground, the beauty of the girls. And the drabness of the houses in the background meant a lot to me—they remind me of many of the tenements in New York.

The first time I went abroad was in 1956 to make *Trapeze*. All told, I spent five and a half months on the film in Paris. The first month was great. Then time began to drag, and by the finish of the picture I was really homesick. I shot the stance of the ballerinas while we were making *Trapeze* and the girls were waiting for the next scene. I feel the whole spirit of youth, the vitality of the young is imaged in these legs. Even when these girls are relaxed in a moment of rest, there was something danceful about their feet. The ragged shoes are typical of all ballerinas, even successful ones as these.

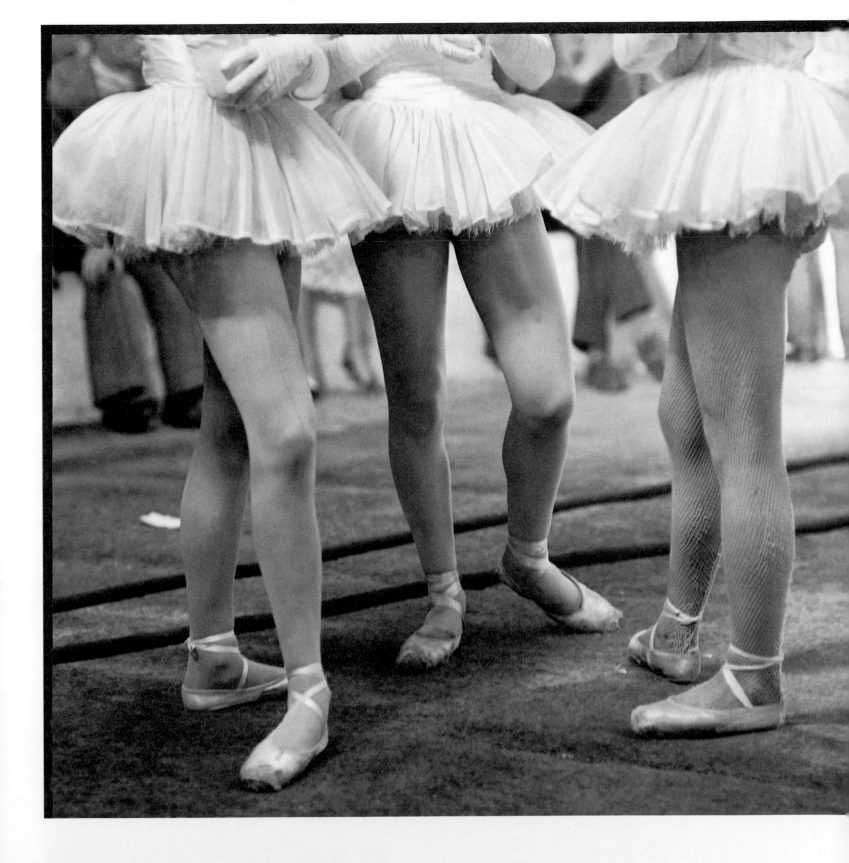

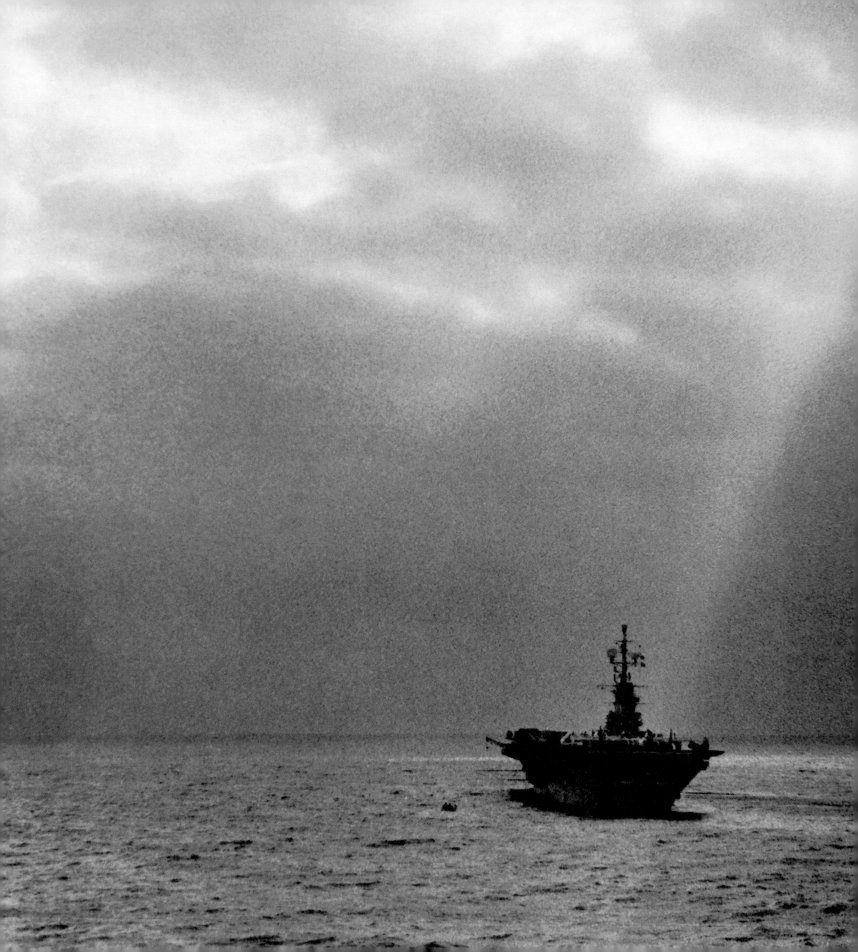

TONY CURTIS

The day I made this shot, I was standing on the deck of the Italian liner *Christopher Colombo* in Genoa, anxiously waiting for the trip home to begin. I looked out into the harbor, and anchored there was this American aircraft carrier. As I looked at it, the shaft of light broke through the clouds and shone down on the ship. I don't want to sound hokey, but it looked to me like the finger of God. Maybe it was patriotism which made me see it that way, but when you travel abroad and see something of home, your thoughts do go somewhat ethereal. Anybody who has been away for a long while will know what I mean, will understand how I felt. I made 11 pictures of the scene with my Contax, and this is the one that turned out the best.

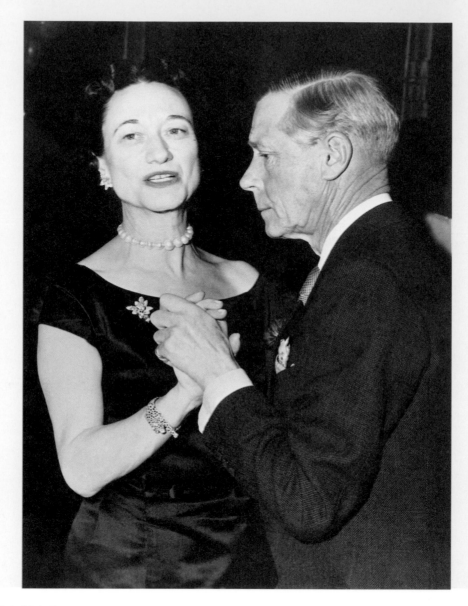

SHERMAN BILLINGSLEY

The only time I ever take a picture is when the girl sets the camera. I just aim and fire. That happens two or three times a night, whenever I see somebody I know and I like, whether a big name or not. With me it's a gag thing. I took this of the Duke and Duchess of Windsor as they danced in the club one night. They have been in the Stork Club some few times. They are very friendly people, very easy to be with. I remember one night they were upstairs at a private party and three soldiers who had been decorated were downstairs and said they'd like to meet the Duke. I told him, and he was pleased to spend an hour with the boys. I have an autographed picture of the Duke and Duchess, but it is not one of the shots I made. It was one of those taken in a studio.

My husband, Charles MacArthur, was an avid amateur photographer and he
often tried to interest me in taking pictures, but he never did. But when he died
I took up the Leica where he let it drop. I am now an enthusiastic shooter and
this picture is one of my first shots. It shows my son, James MacArthur, sitting
at the right, with some of his young friends at the pool of Mr. Nunnally
Johnson, the producer, director, and writer of films.

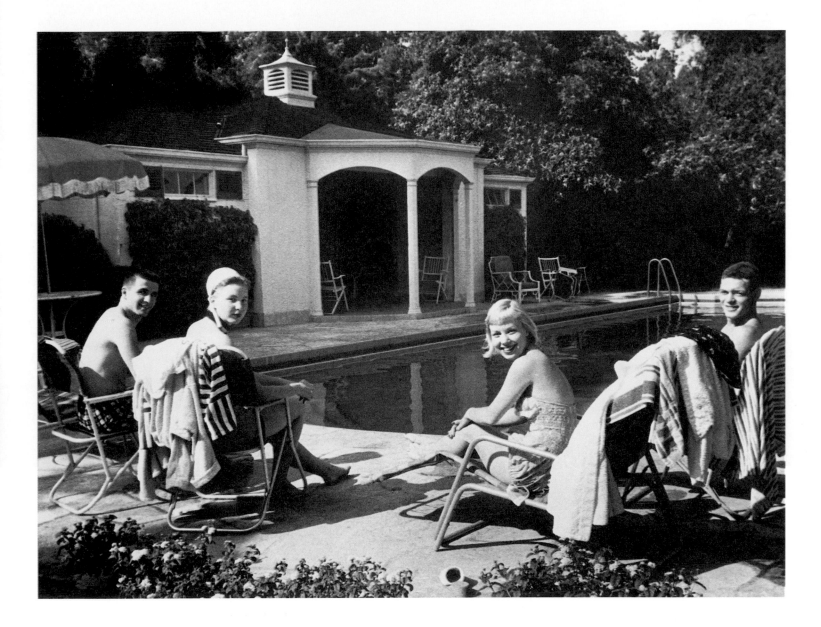

Tony is the one in our family who always takes the pictures, but this time—we were taking a walk along the Seine in Paris—he was so fascinated with the man and his dog, I was able to fire away with his Contax. The Frenchman boasted about his dog a mile a minute but Tony didn't really understand a word he said. I caught Tony looking very pensive in the picture below, as he waited for instructions from a French photographer who was shooting him for a magazine layout. This was outside Paris. I love these shots.

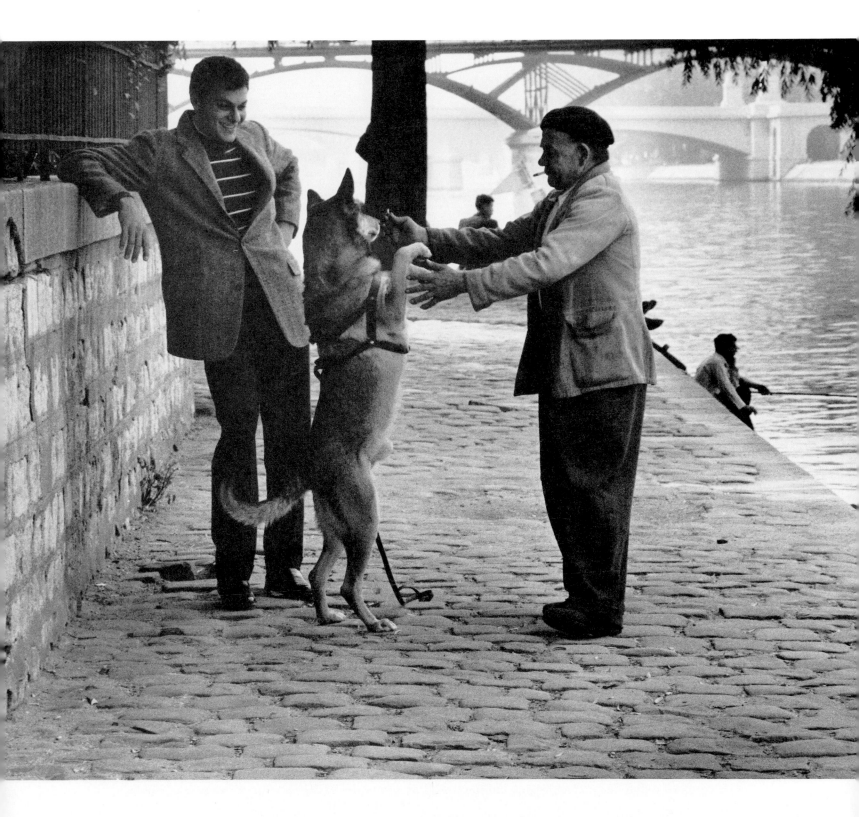

HAROLD LLOYD

I stopped counting the number of stereo shots I had made when the figure reached 100,000. That was some time back. I shot 25,000 in the past year alone. My stereo pictures and my name have been so closely linked to the Stereo-Realist company, many people think I own it, but actually I have no financial interest in the firm at all. I am happy to promote the Stereo-Realist simply because I like the camera so much. I shot all of these in stereo, of course.

Because of the mood of the picture (right) and the expression of the girl, I have titled the photograph "Sultry."

I use the close-up of the eye (page 53) to conclude many of my exhibitions of stereos. I show this slide last and close, saying, "I'll be seeing you."

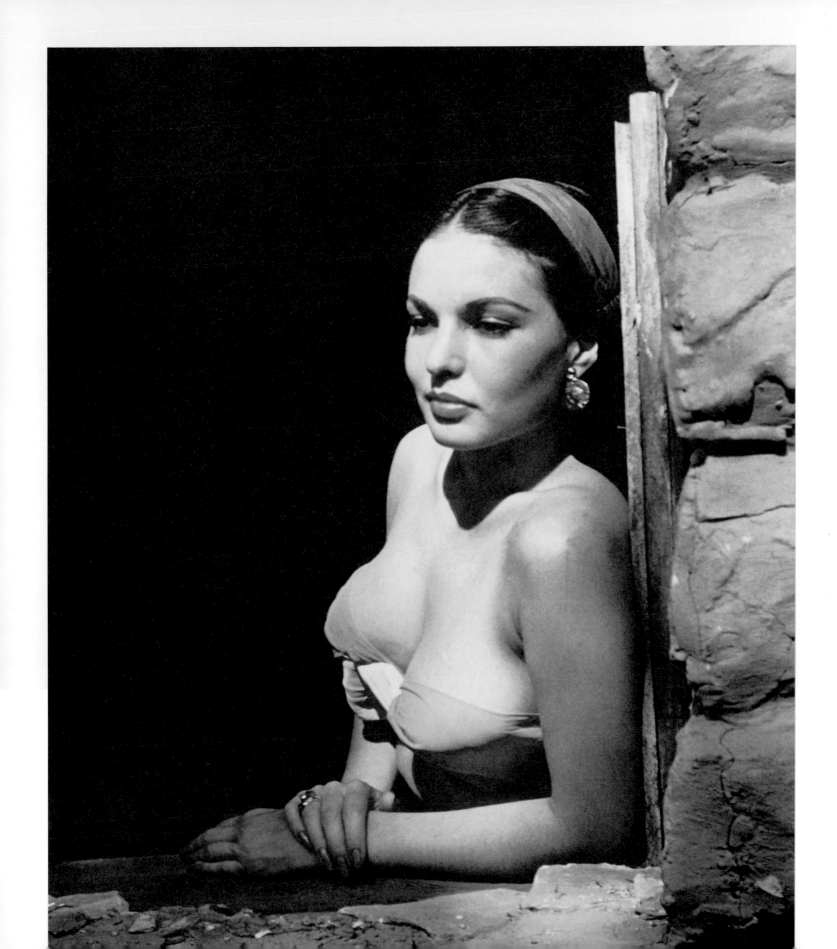

HAROLD LLOYD

52

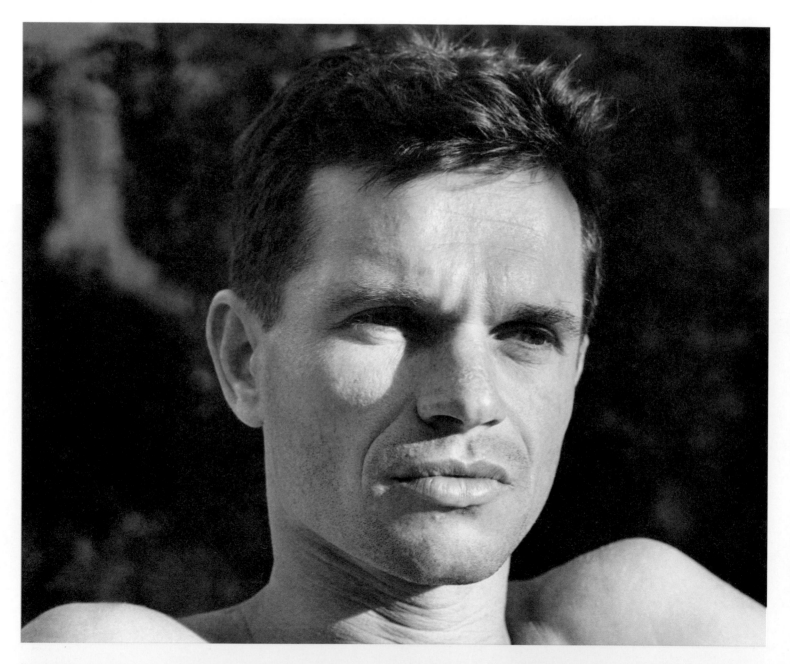

DANNY KAYE

I had just returned from Japan, where I bought a new Nikon—with all kinds of lenses and filters and stuff—and Mike Kidd and Mary Kidd and all their little kids were visiting at our house. I was just fooling around with the camera like a kid with a new toy, learning how to operate it, when I noticed Mike sitting beside me. The afternoon sun had dropped very low and was casting some very interesting shadows on his face, which is sort of angular and bony, anyhow. I set the camera, turned and shot the picture without any posing or preparation. It turned out to be a very good picture of Mike, more than just a portrait, but a character study that, to me, tells a little bit about the man.

I don't make any pretenses about being a photographer. I'm a photographer about like I'm a symphony conductor. But in photography, like in anything else, occasionally a rank amateur does something by accident that a professional might have been trying for years to accomplish. In golf, once in awhile a real duffer happens to hit a perfect shot. He doesn't know how he did it, but there's the ball, 250 yards down the middle of the fairway. Well, this picture was a once-in-a-lifetime perfect shot for me.

I learned early in my career that there is nothing bush about the way *Life* photographers go about the business of getting their pictures. When photographer Hi Peskin (right) and correspondent David Zeitlin (the author of this book) stood out on the bouncing bow of Jimmy Albright's sportfishing boat in the Gulf of Mexico to get some shots of me readying my tackle for bonefish, I couldn't resist shooting them. I took my Leica and made this picture of them trying to keep their balance and get their shots at the same time. Before the trip was over, Peskin did get some terrific pictures. Of course, I gave him something to shoot at, nailing a 10-pound bonefish on a fly.

I have a movie camera and a Rollieflex besides my Leica, and my business manager, Fred Corcoran, just gave me a Nikon. I get my best results with the Rollie though. Photography occupies what extra time I have, and gives me an everlasting memory of my trips. When I look at the pictures I took on a trip, I always wish I had shot more. I can always think of things I should have shot. For me, though, the most fun is developing my own film and making my own enlargements. That's the way you get the best results, and the better results stimulate your interest all the more.

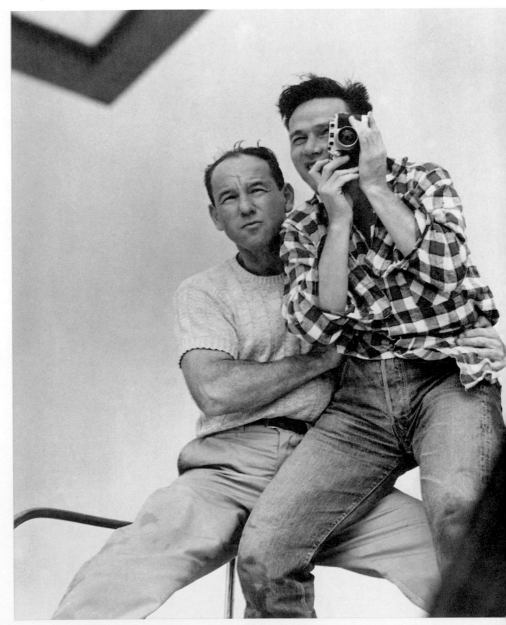

ESTHER WILLIAMS

The one thing that tickles me most about this picture—which I took underwater with one of those Brownies inside a plastic box—is that Suzan, who was only 15 months old at the time, looks so natural, like a water sprite, as if the underwater world were her natural habitat. Suzan learned to swim when she was a year, just about the time she was learning to walk. She took to the water so soon because her older brothers were always in the pool, and most of the time they were swimming underwater, or diving to the bottom of the pool to fetch things. So Suzan started swimming sooner than I would have encouraged, and was always paddling around wide-eyed and watching as she is here, because she wanted to see what her brothers were doing down below. I nearly drowned myself laughing in a face mask many a time, watching this little one paddling around, observing us at the bottom of the pool with this expression of self-satisfied nonchalance.

DEBBIE REYNOLDS

Eddie and I have all kinds of fancy cameras—Rollieflex, Polaroid, Stereo—but I can't work any of them. I've taken lessons but still can't. I really don't like to take pictures, but I realize how much they'll mean to us in later life so I make myself do it. So I shoot with a Brownie, my old reliable. I just punch the button and it goes off.

The picture of Carrie and me in my mother's pool in Burbank is even rarer because Eddie took it, and he just never shoots pictures. I took the others.

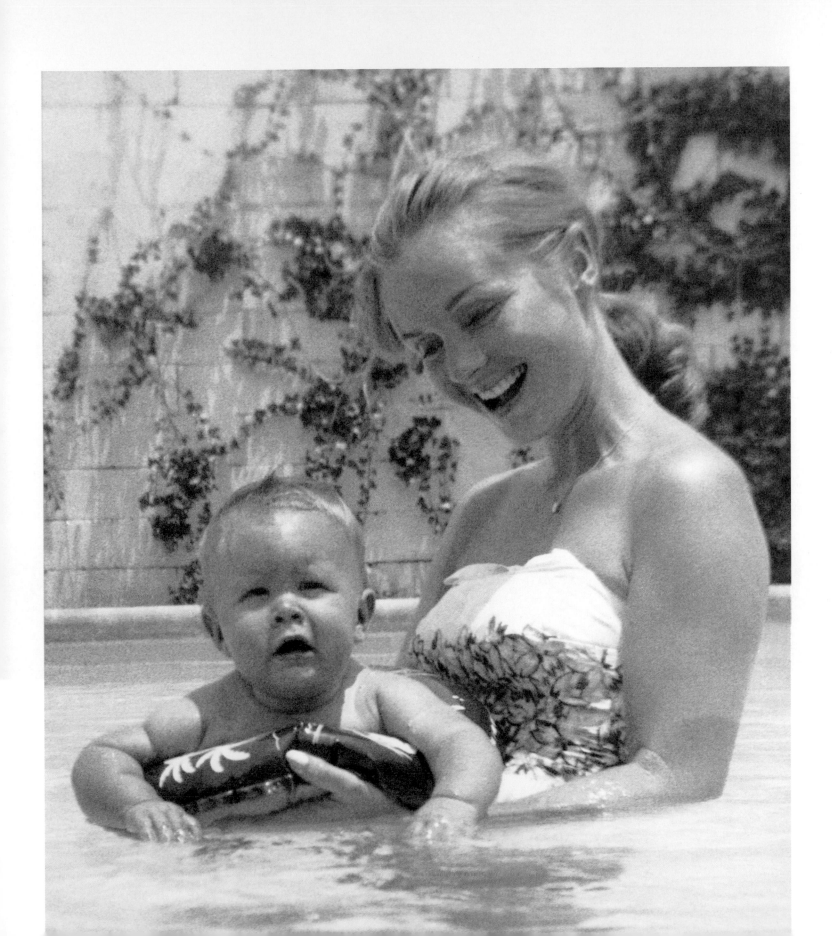

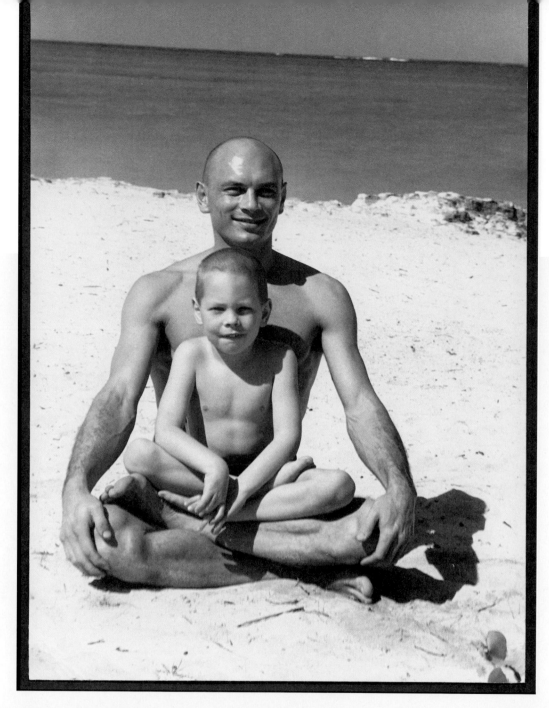

LELAND HAYWARD

I have been shooting pictures for a long time and I carry a well-equipped camera bag with me wherever I go. I love shooting pictures because I love to make permanent records of fleeting moments, of passing sights. The wonderfully symmetrical pattern of healthy arms and legs belonging to Yul Brynner and his son, Rocky, would have been just another interesting sight at the moment if I had not made this picture. Now, because of this snapshot, we can all relive the moment and the fun of the occasion—a Nassau vacation—any time we look at the photograph.

The picture at right, however, was taken for completely different reasons: it had a premeditated purpose. Tex McCrary had gone to Korea on a fast flying trip, but a few weeks went by and his wife, model Jinx Falkenburg, began to feel the trip was not going fast enough. She asked me to make some pictures of her which she could send to Tex, the kind of pictures that would bring him home. This is one of the several I took, and one of those Jinx sent to Korea. They worked.

LELAND HAYWARD

The smile of Mary Martin is known to millions who have seen her on stage and on television and in the movies. Yet I think the great inner mirth and loveliness of the woman is captured with this candid picture I took with my Rollieflex. Left: My wife and Truman Capote revving it up.

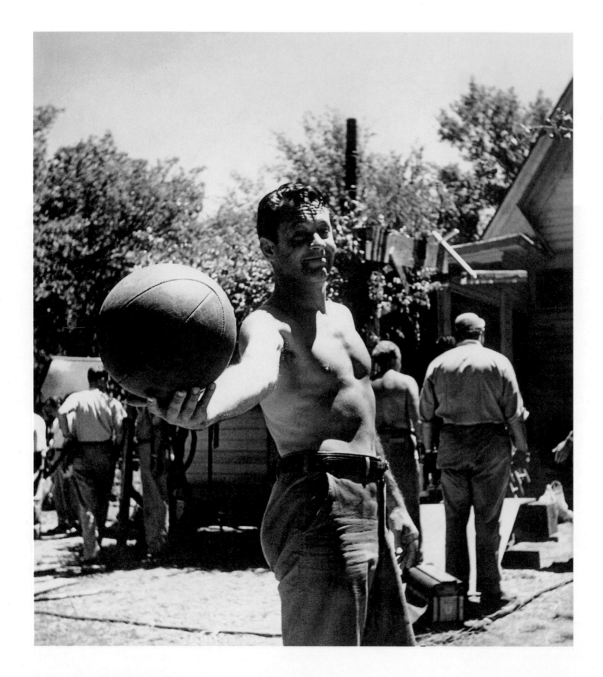

ROSALIND RUSSELL

I shot both of these pictures while we were on location in Hutchinson, Kansas, making the film *Picnic*. All during our stay, tornadoes were devastating the country all around us, but thank goodness none ever hit us directly. But they did create all sorts of phenomenal weather conditions. One evening, I looked out of my hotel room and saw a magnificent double rainbow arched over the grain elevators. I set up my camera, a Stereo-Realist, to picture it, when this bolt of lightning flashed right through the sky. I consider a lightning bolt for a rainbow a fair swap.

Of course, you recognize the man carrying the ball as William Holden. For me, this picture is somewhat symbolic of Bill, because he was really on the ball all during the long shooting of *Picnic*.

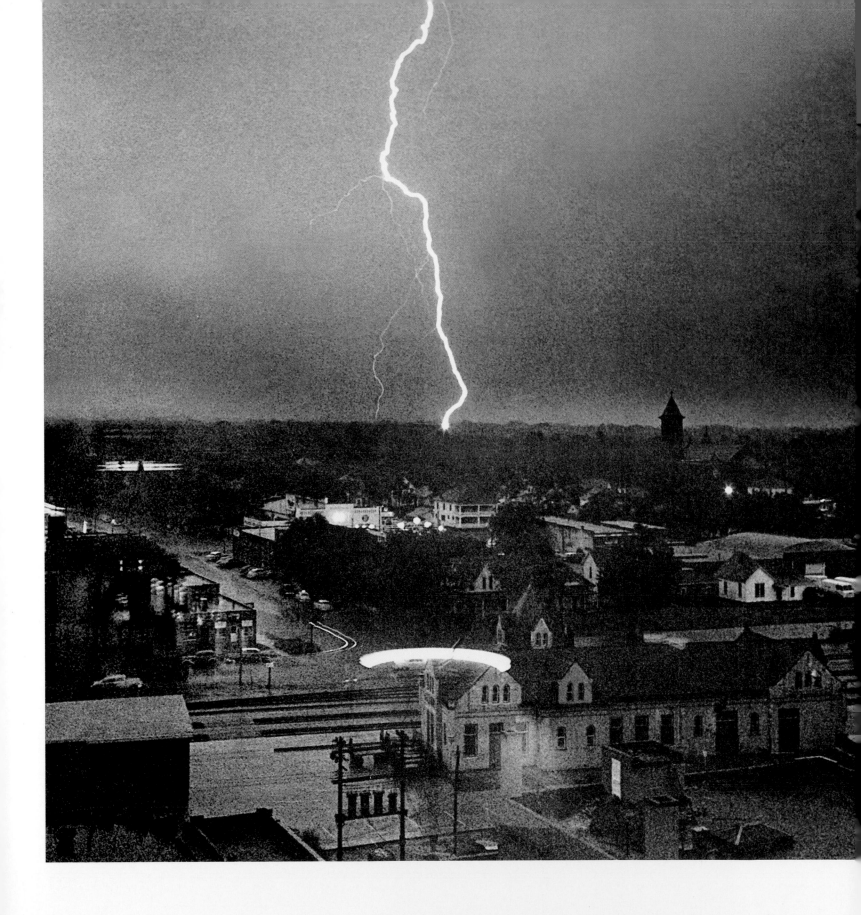

I had no idea I was documenting the blossoming of puppy love when I took these pictures of my daughter Melissa Ann and Stewart Rand Korshak, along with my husband George Montgomery, on the beach at Waikiki on a Hawaiian vacation. The children had just returned from a ride on the catamaran, and as they walked up the beach, I kept shooting them, not for any special reason but just because I am always shooting. Of course the children, who are now nine and have been best friends since they were five, did look cute together, walking hand in hand. Then I loved the moment when Stu whispered in Missy's ear, and the instant she whispered back in his. It wasn't until after the film was developed that we discovered that the heart had appeared on his tummy. When I saw it I could hardly believe it. I do almost all of my shooting in black and white. I don't like color much; you can't share it with people; setting up a projector and all is too much of a ceremony and too much of an imposition. I used to develop my own film and print my own pictures, but I just don't have the time anymore. But I carry a camera with me all the time, either my Rollie or the Nikon, or if nothing else, my Minox in my handbag. The day I took these I brought the Nikon to the beach in a sandproof bag. But obviously, pictures like this make the trouble worthwhile.

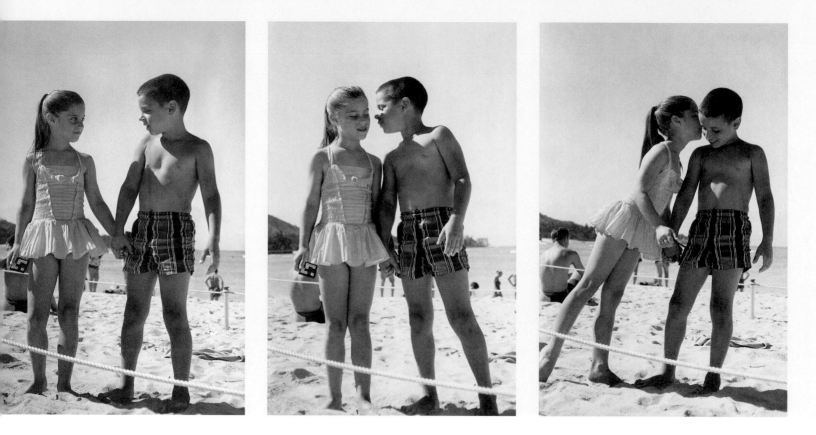

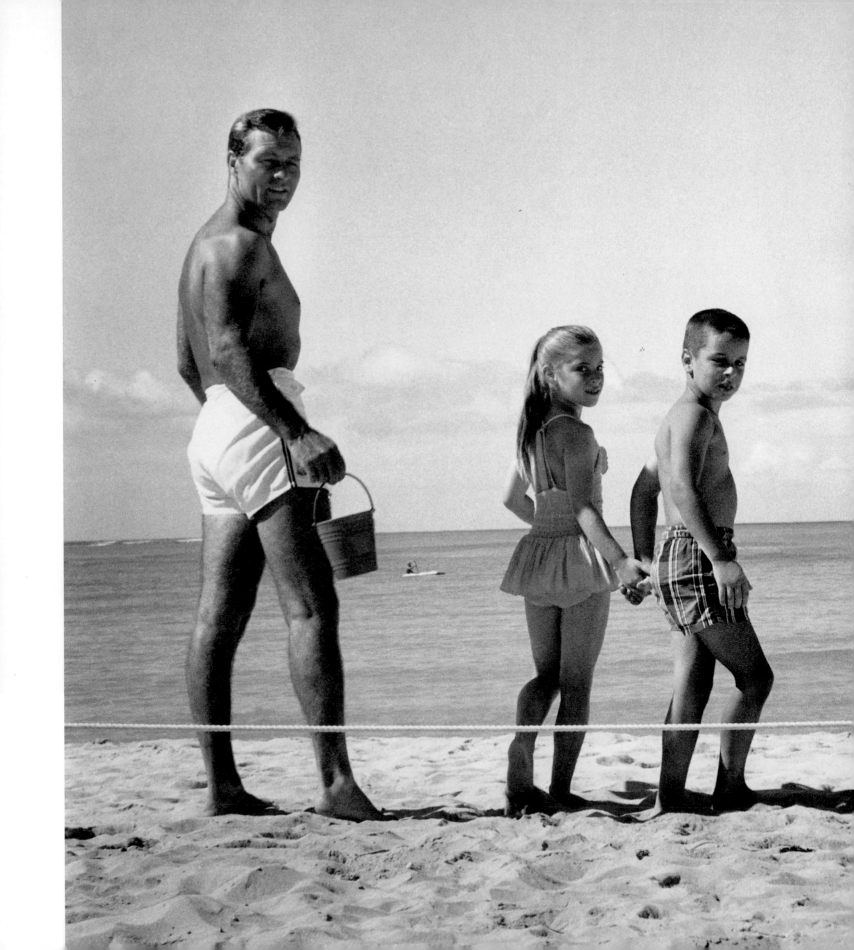

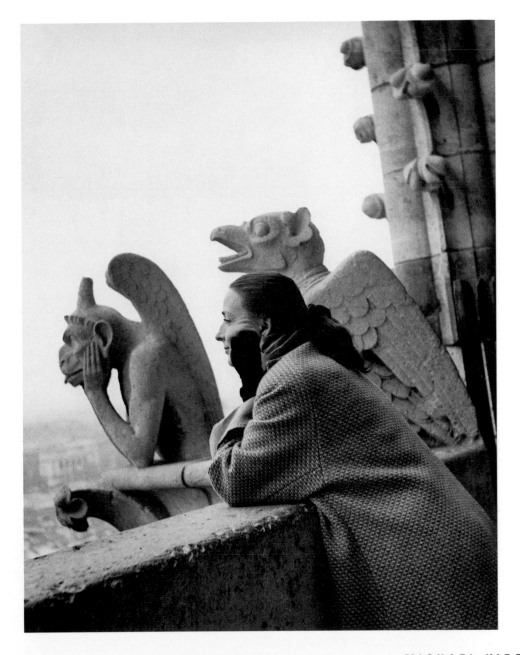

MICHAEL KIDD

I took this photo of my wife, Mary, high up on Notre Dame Cathedral in Paris. To me, the picture presents three timeless figures, one a woman, two of stone, silently observing and appraising the turbulent flow of life beneath them, yet always maintaining their enigmatic serenity. Growing up includes covering up, increasingly, and in many ways. The picture of my wife and two daughters Kristine and Suzanne (opposite) in progressive stages of dress says this to me. Their reluctant departure from the beach symbolizes the universal desire to linger, bare-footed, in the uninhibited freedom we enjoyed as children. I have always tried to take pictures that look into the emotions of people. In photographing my children, my chief subjects now, I attempt to record occasional glimpses of them in the process and wonderment of growth.

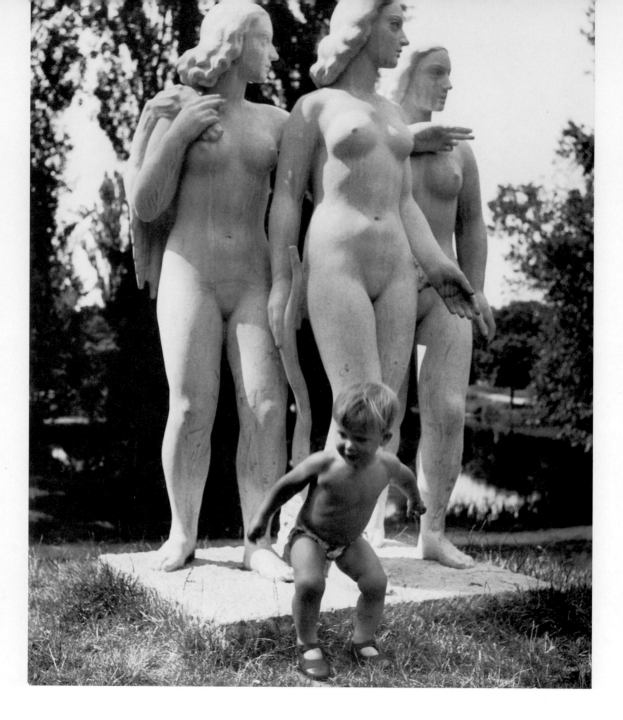

FRANK SINATRA

Jimmy Van Heusen and I were riding around Paris in
a chauffeur-driven car back in 1950. It was my first
trip to Europe and we were gawking like tourists. I saw
this kid and the statues, and yelled to the driver to stop.
I ran out of the car and grabbed the shot with my
Rollieflex. I think it's real cute.

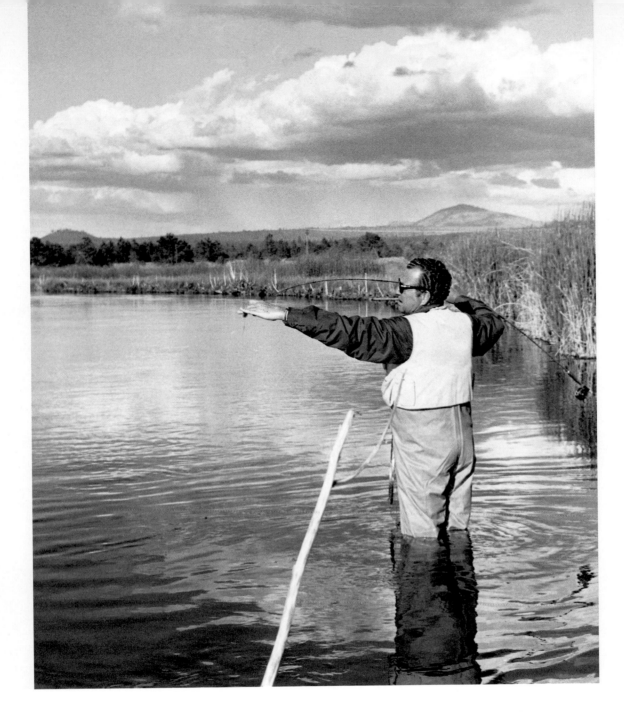

This shot is novel because, though Mr. Phil Harris is often tangled up, it is rarely out of doors. I shoot pictures incessantly, and always with a Rollieflex. I think people like to get them as souvenirs. That is their appeal to me.

If the time ever comes when Miguel ceases to look like Joe (his father José Ferrer), this picture (opposite) will prove that they were once one face. A friend of ours looked at the photograph and asked, "When did they start making Joe Ferrer baby dolls?" I shot these pictures with Joe's Rollieflex but have a Minox and a Realist of my own and do most of my shooting with them. I take pictures as a record of my children. On reflection, occasionally you forget the details of a given situation involving the kids, so I take pictures of them and keep them as a ready reference file of their lives.

The portrait of José Ferrer (below) is his favorite and my least favorite. At the time he was playing Captain Alfred Dreyfus in a film in England, which accounts for the moustache. The hat is, of course, self-explanatory.

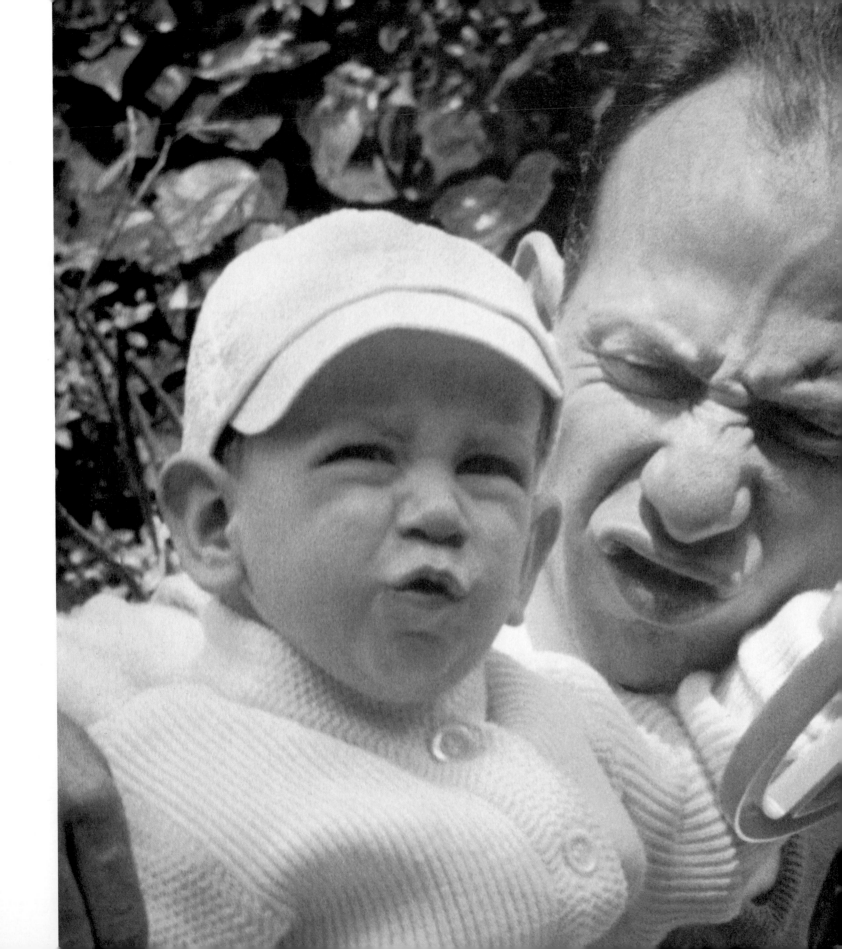

KIRK DOUGLAS

A good actor must, in many ways, still be a small boy. If our make-believe is to
seem real, we have to approach it with the dedication of kids playing cowboys
and Indians. That's why children are my favorite camera subjects—uncon-
cerned, unself-conscious, and just wonderful. If, in this picture, my son Peter
looks concerned or self-conscious, it is due perhaps to the fact that he was
wearing his birthday suit. But he still looks wonderful.

LIBERACE

This picture should prove once and for all that my brother George loves to eat. I shot it with my Rollieflex at a party I gave on the patio of my house. I have a whole array of cameras and chose photography as a hobby because I can follow it without taking a chance of injuring my hands. I wouldn't dare try tennis or golf; I must stay away from all sports. But photography is completely satisfying. It gives me a chance to have my own personal memory file of my close friends and their doings.

BETTY FURNESS

These pictures are typical of what I like to shoot. I don't like "things." I like people. To be able to look at pictures of my friends means a great deal to me. I keep about a dozen 5x7s or 8x10s framed in my apartment at all times and change them from season to season as I acquire new pictures. I took the one of Yul Brynner in his dressing room while he was making up to play the "King." It was in April 1953. The lady (with the rose) is Anne Shirley Lederer, and I made the photograph of Frank Sinatra aboard the *Celeste*, a boat he chartered to entertain friends over the Fourth of July weekend, 1957. The man (on page 79) is James Mason. If you look real closely, you will note that his crossed legs are reflected in his dark glasses. I would love to say that I did this on purpose but frankly, I didn't see it until I had the picture enlarged.

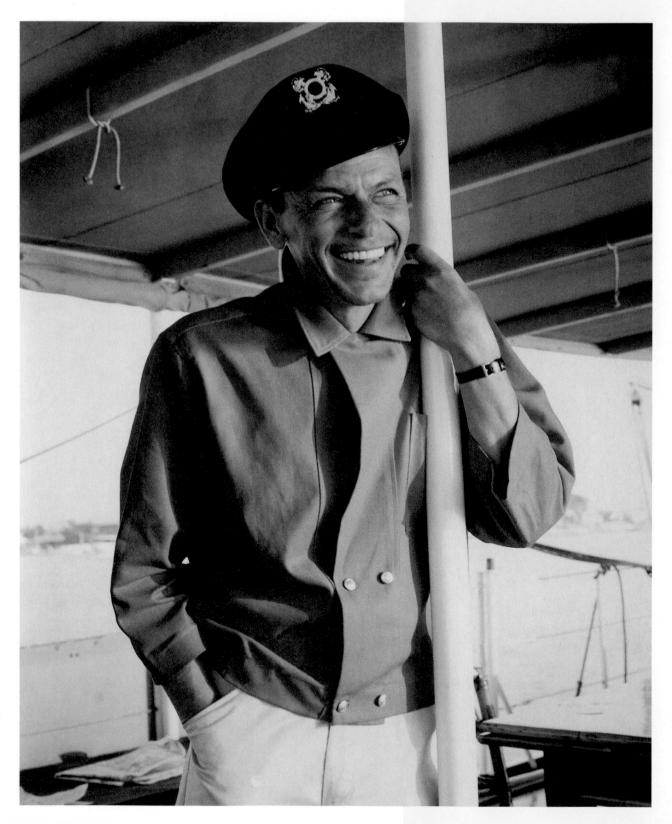

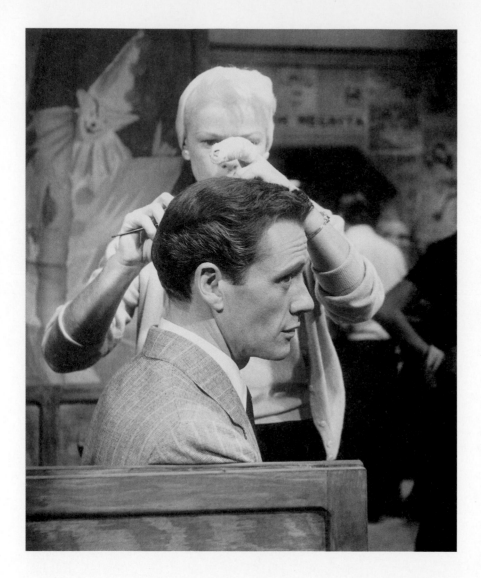

ED SULLIVAN

Since Eastman-Kodak joined our show, I do have a much livelier appreciation of photography, and I am waiting for spring to roll around so I can use all the equipment they sent over to me. I've taken some pictures of our three grandchildren up in the country and they came out rather well.

I took these when I visited the set of *The Sun Also Rises* in the Churabusco Studios in Mexico City. The man behind the inevitable cigar at right is the maestro himself, Darryl Zanuck, the producer, looking on as a scene was rehearsed.

I was fascinated by the intensity of the hairdresser as she ministered to Mel Ferrer, but I was a little baffled as to how she could work with that finger wrapped in bandages. But she did.

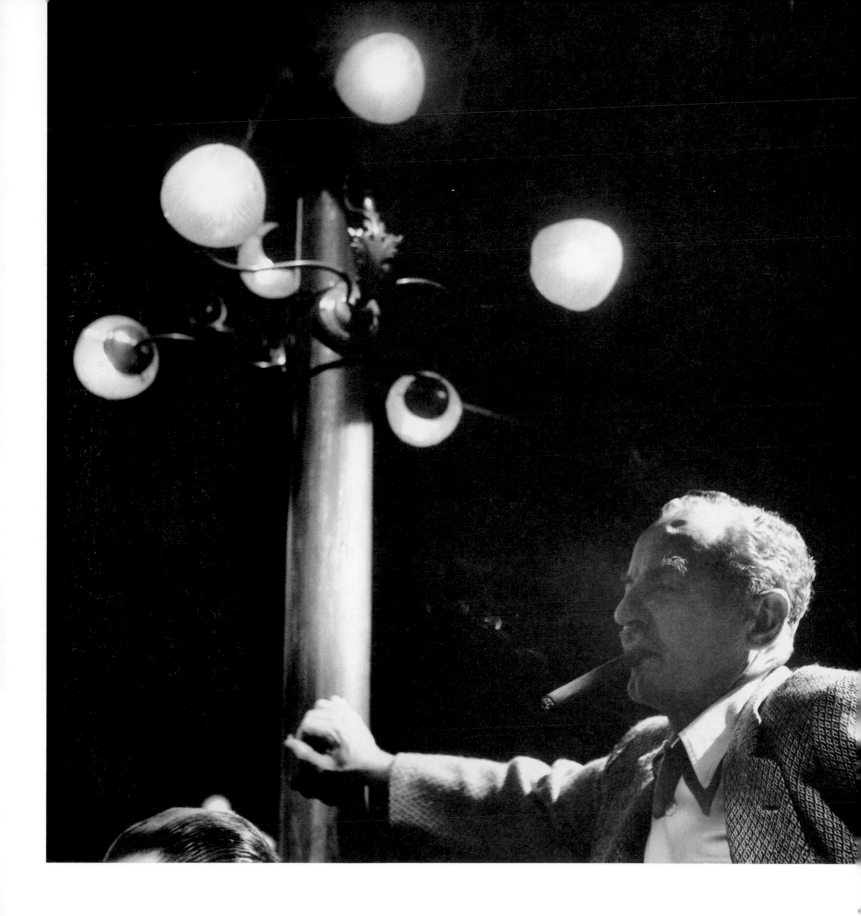

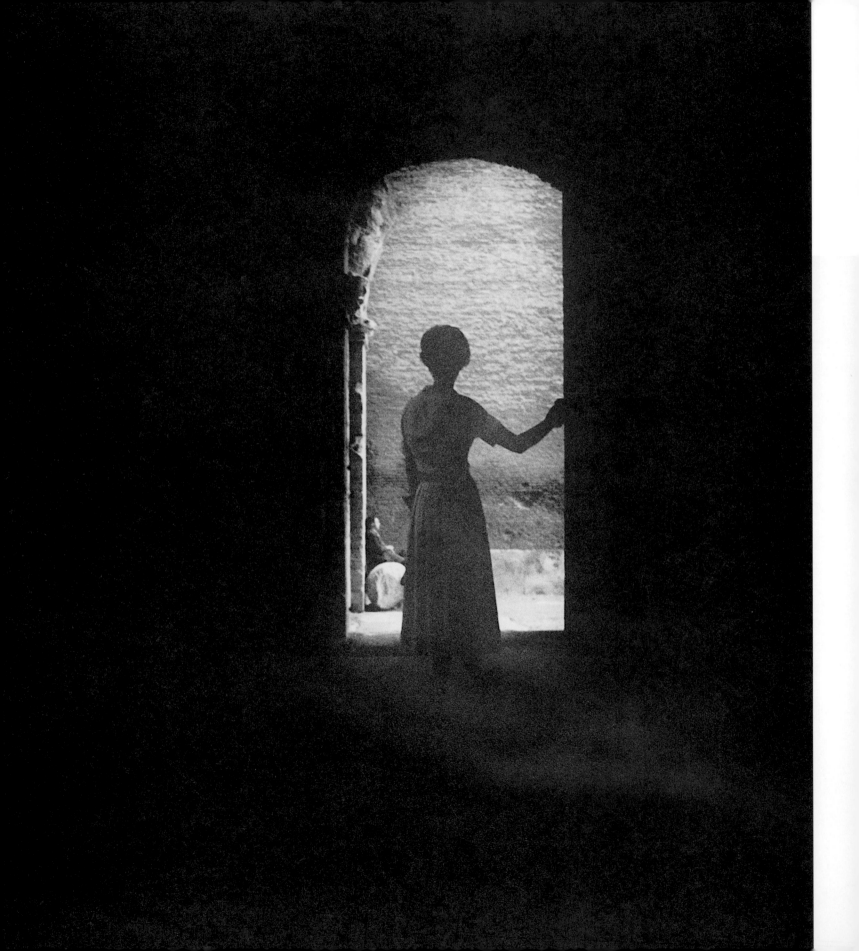

I am not an avid amateur photographer, but my Rollieflex is the key to a world of enjoyment, especially on holiday trips when I use it to make a record of the places I have been and the people I have come across. I never set out in search of subjects to photograph, as so many of the avid shutterbugs do, but simply shoot when I see something that catches my eye and my fancy. All of these pictures are examples of that: the portrait of my stepdaughter, Amanda Mortimer, in her vacation hat (page 84); that of Yul Brynner—certainly no boon to barbers—administering a clipping to Leland Hayward during a vacation in the Bahamas; the picture of my wife (left) standing in the doorway of a ruin in the south of France. The two sailors (page 85) were also shot in southern France.

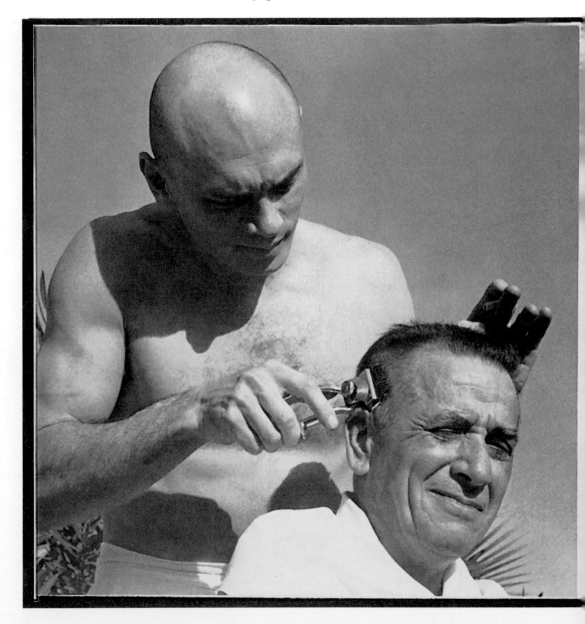

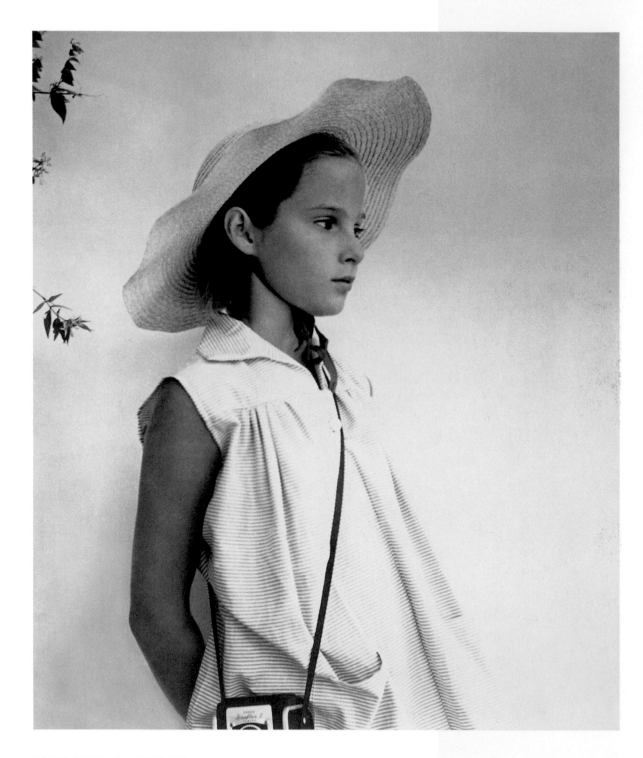

WILLIAM S. PALEY

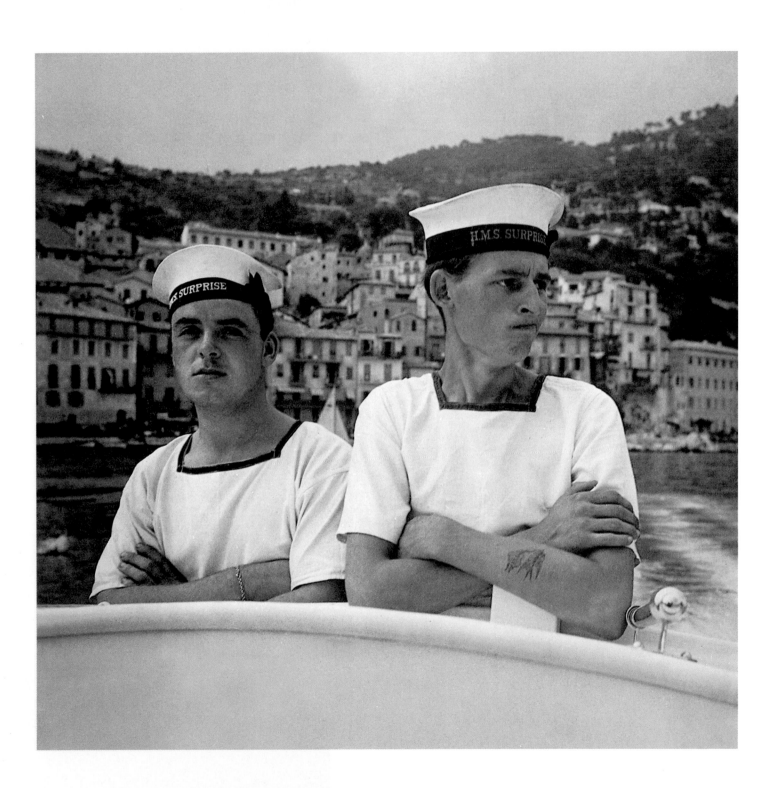

Jerry Lewis bugged me on photography when he gave me a Contax 3A about four or five years ago. At first I was very casual about taking pictures, but as my interest grew, photography came to mean more and more to me and now I am as serious about photography as any professional. The way I feel about hobbies, I can't play games like golf or tennis. Any hobby I have I've got to create something or it is no good for me. Photography is good because it gives me the chance to try and be creative. I think a performer who takes up photography has an advantage over non-entertainers who start shooting pictures. As an entertainer I can anticipate the climax of a person's activities, can shoot at just the right moment to capture the high point. Photography is also a great way to express one's inner feelings, and unlike a painter, a photographer can communicate with certainty exactly how he feels about a subject. If he captures what he feels, all the people who look at the photograph will know just what he meant and understand the feeling. When a painter shows one of his paintings, chances are everybody will interpret it differently, no matter how specific the artist was in what he had to say. All of these pictures gave me considerable satisfaction. The lady at the microphone is Carmen McRae, a very hip, astute woman who digs all forms of good modern music. The photographs capture her inner beauty, her nice quiet type of dignity. I like the picture at the right because the character the actor is playing is more recognizable than the man. For that reason, he liked the picture too, and the "he" in this case is a man I've always admired: Orson Welles. Orson is made up here as *The Merchant of Venice* for an appearance on *The Steve Allen Show*.

I am never without a camera and am always getting new ones. Right now, in addition to that Contax Jerry gave me, I have two Rollieflexes, a Hasselblad, two Nikons, a Canon, a Leica, a Polaroid, and a Praktica. I have complete outfits for both Nikons, and several lenses for the other cameras as well. I have a 180mm lens for the Praktica; the super wide angle lens for the Leica; the wide angle, the normal, the 135mm, the 250mm, and the 400mm lenses for the Hasselblad. There is no end to the amount of gear I've accumulated, but I love every piece of it.

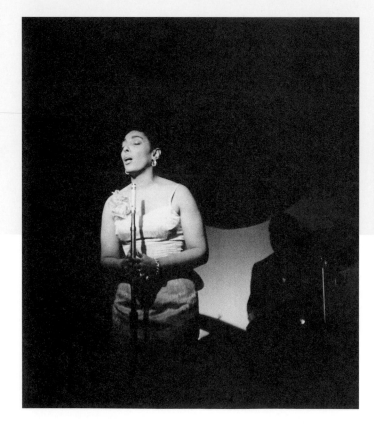
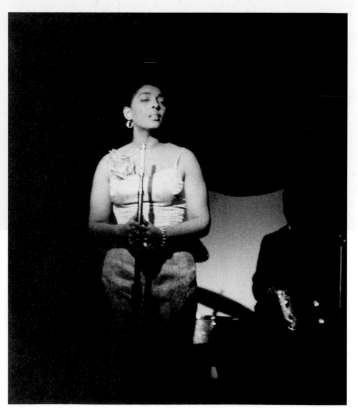

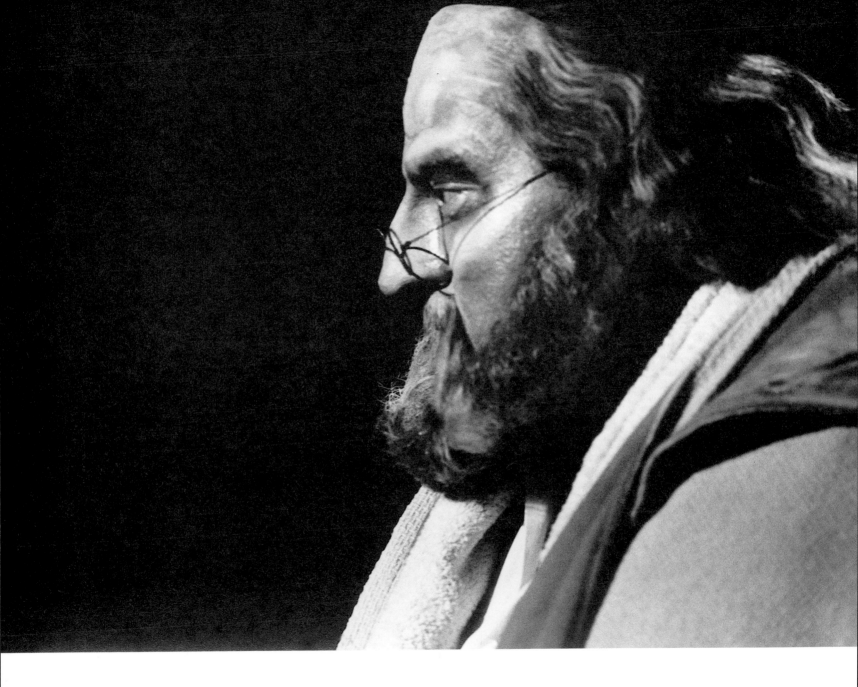

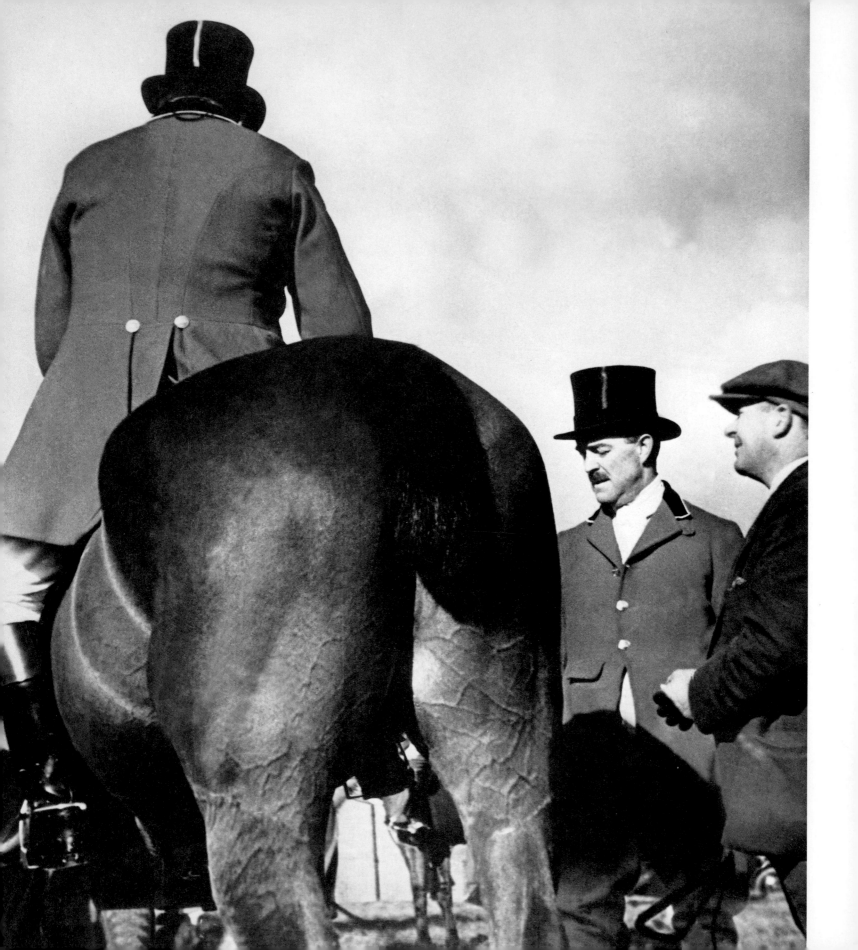

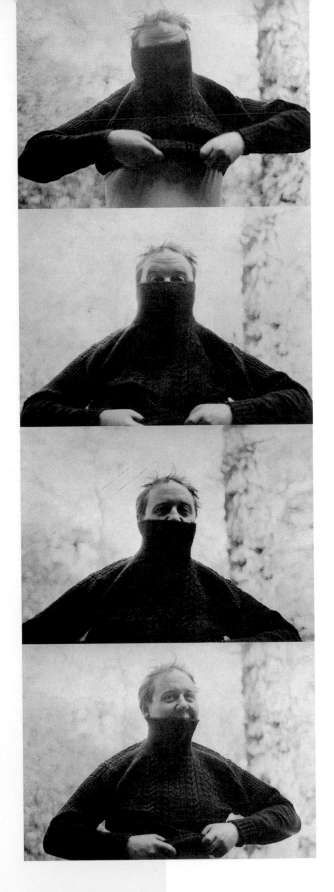

I started shooting pictures as a baby equipped with a Brownie. Sometimes I like to poke fun at people with my pictures, and I really think I do just that quite well with my carefully angled picture of the English riding gentleman. I think the picture sums up fairly well my attitude toward what is, at times, a pretty stodgy group. The series of my husband, Charles Laughton, pulling on a heavy woolen sweater comes under the heading of family fun, and just delights me.

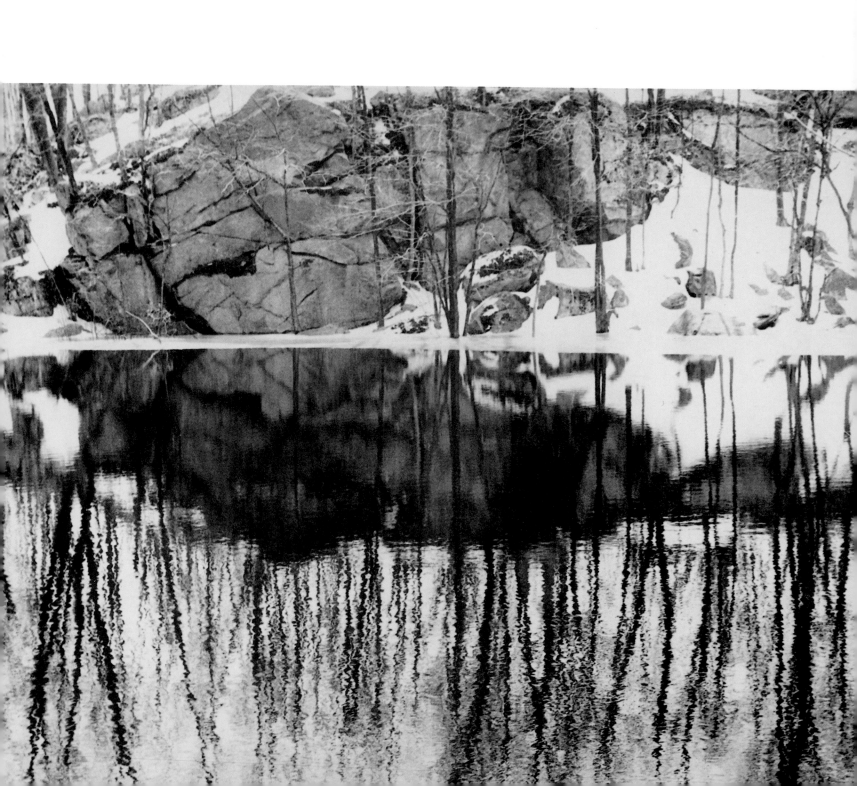

I have too much respect for fine photography to even pose as a photographer. I'm just a man with a hobby and I enjoy it, but I don't know whether any of the stuff I have shot is worth looking at except for me and my family. Even my kids don't think I'm very good. I rarely try to be arty, and the photograph at the left is not as arty an effort as you might think. It is simply the reflected image of a snow-covered edge of the pond at my home in Connecticut. The man in the cap is John Steinbeck. I will say I think the picture of John is really sort of striking.

GENERAL ALFRED M. GRUNTHER

No one will ever select me as a *Life* photographer. I consider myself lucky when I snap the shutter and a blank does not result. When I was the Supreme Commander of the Allied Powers in Europe, I recorded the visits of many distinguished persons to our home at Marnes-la-Coquette, just outside Paris, including Mrs. Clare Boothe Luce when Ambassador to Italy. I can't even give sound reasons why one picture appeals to me more than another. Some pictures I like, and others do not appeal to me. That's all there is to it. It is the same way with my taste for olives.

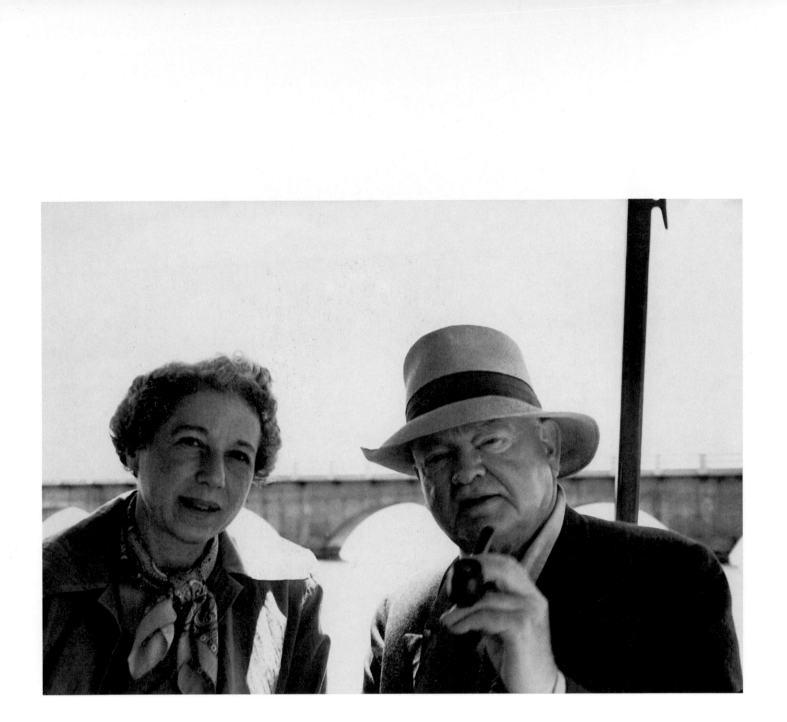

ADMIRAL LEWIS L. STRAUSS

I took this photograph a few seasons ago off the Florida Keys, of my two favorite fishing companions, ex-President Herbert Hoover and my wife. The camera was a Leica but I do not recall the exposure details. The chief interest resides in the fact that although the faces are against a strong backlight, the details are clear and without opaque shadows. My interest in photography began with my boyhood. Ever since, it has been a continuous source of adventure, delight, and even profit. Among my most cherished possessions are the pictures of those I loved, taken with a simple box camera more than half a century ago.

HARRY S. TRUMAN
FEDERAL RESERVE BANK BUILDING
KANSAS CITY 6, MISSOURI

February 23, 1956

Dear Mr. Zeitlin:

In reply to your letter of the tenth, I remember taking only one picture in my whole life.

When I was in the White House I borrowed a camera and took a picture of all the members of "The One-More Club," but I do not know where the film is or even if there is a copy of the picture itself.

I regret it very much, but I am not a camera fan. *Sorry appear in front of it!*

Sincerely yours,

Harry Truman

Mr. David I. Zeitlin
Life Magazine
9606 Santa Monica Boulevard
Beverly Hills, California

HARRY TRUMAN

I took this picture in January 1956, on Main Street, Brockton, Massachusetts. It is of a group of Brockton young men waving a greeting as they always do when I go through my hometown. I chose it as my favorite because of the particular feeling of welcome I get whenever I'm back in town. The picture was taken with a Rollieflex and the young men in it are, left to right, Malcolm Greene, Lawrence Small, Kenneth Youngstrom, Robert W. Haglof, and Milton Burgess.

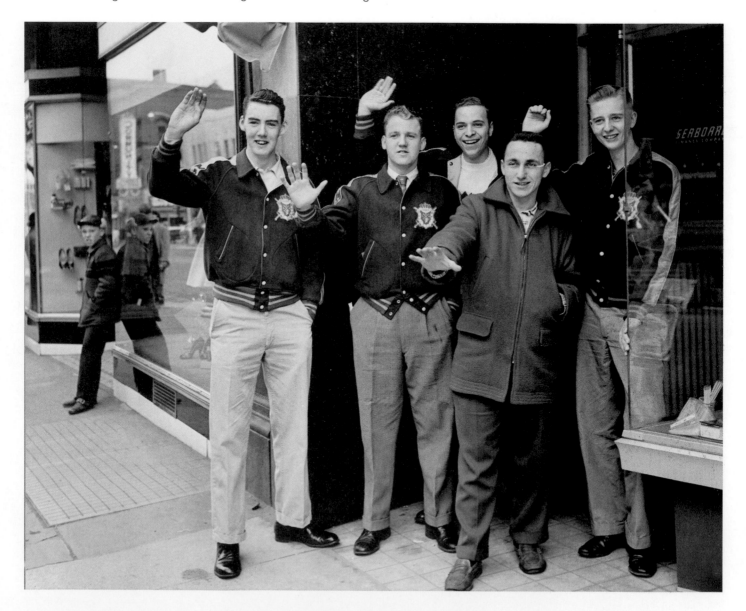

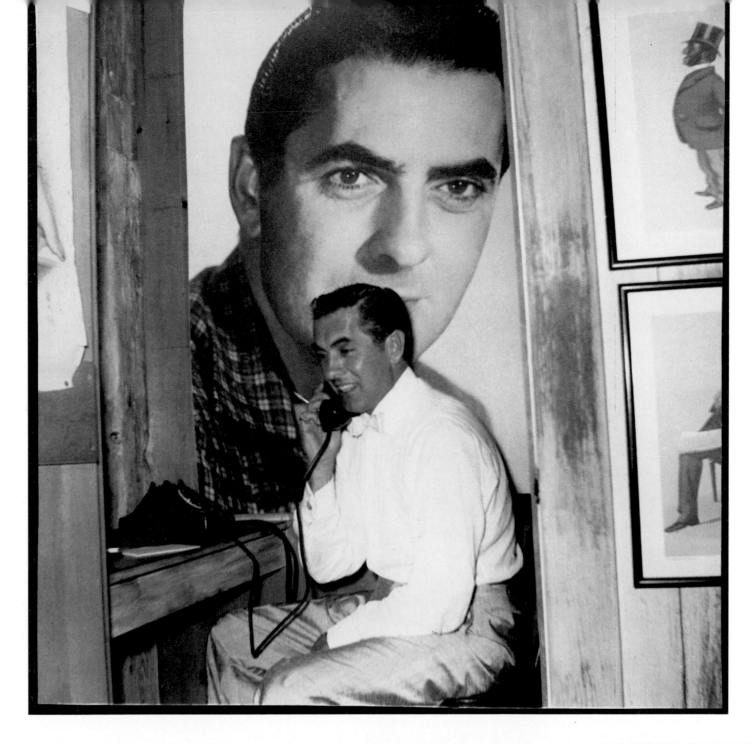

RAYMOND MASSEY

Tyrone Power and Tyrone Power....When my wife asked Ty for a picture of himself, he sent the mural shown on our telephone cupboard. It arrived on Christmas Eve.

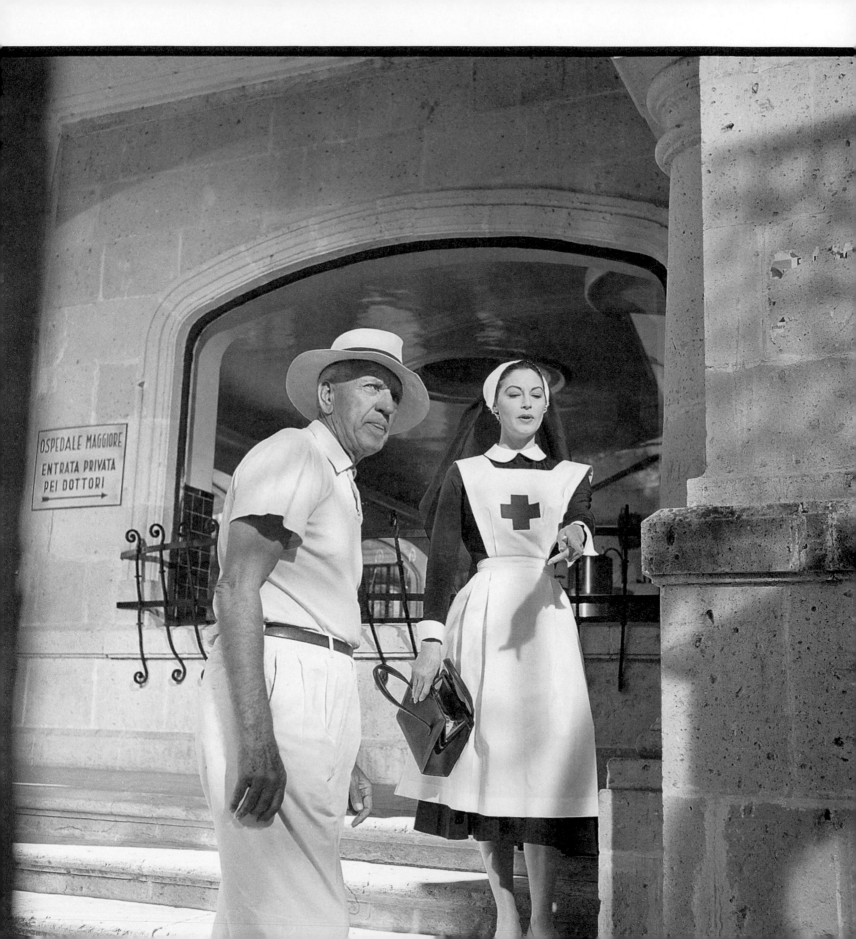

These pictures were shot on the Mexico City location of *The Sun Also Rises*. Above: Eddie Albert and Errol Flynn. Left: Ava Gardner with director Henry King. Tyrone Power died before text was obtained.

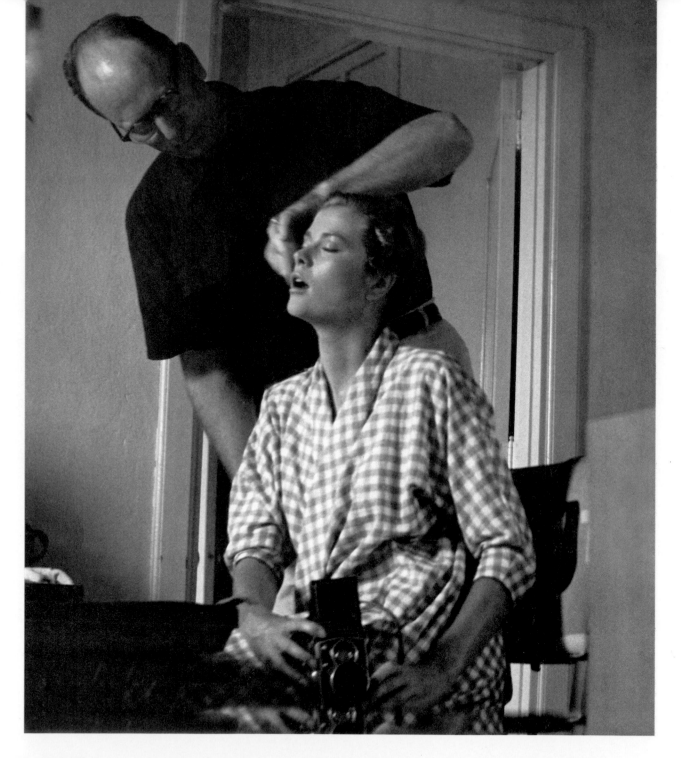

GRACE KELLY

I started taking photographs in earnest in 1953 when I went to Africa for the filming of *Mogambo*. I took the pictures on the following spread (pages 102-103) while on another foreign location, in a small village in Colombia, South America, during the filming of *Green Fire*. The children of the village gathered around us and just stood there and stared at us with these intense expressions. I think they were especially curious about me because I was the only woman in the company. The picture of me above is a self-portrait I made on this location by shooting my reflection in a mirror. The editors of *Life* tried to make a photojournalist out of me, and asked me to take pictures for them on this location. They even loaned me a camera. I shot when I had time to shoot, but *Life* did not publish the

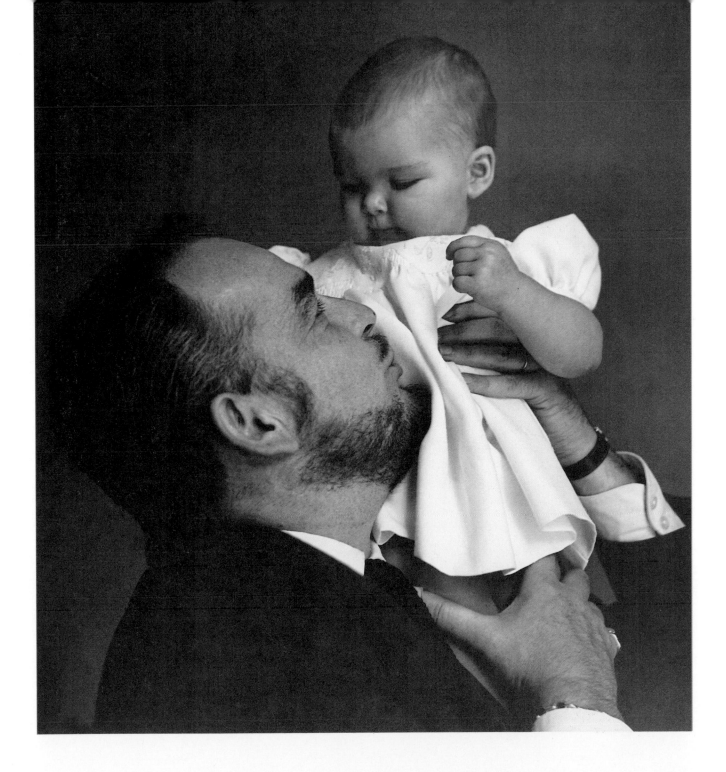

results. Above is one of a series of pictures I took in the fall of 1957, when my career as an actress was a thing of the past. I took this picture of Princess Caroline and my husband, Prince Rainier, in our apartment in Paris. I am particularly fond of [this picture] of Caroline, because it is usually so hard to get spontaneous, indoor photographs of her because she moves so fast. I shot [it] with a Rollieflex and do most of my shooting with one, although I sometimes use the Prince's Leica—when he's not looking. The Prince, by the way, is a superb photographer. He has all sorts of equipment and has a lovely darkroom in the Palace in Monaco.

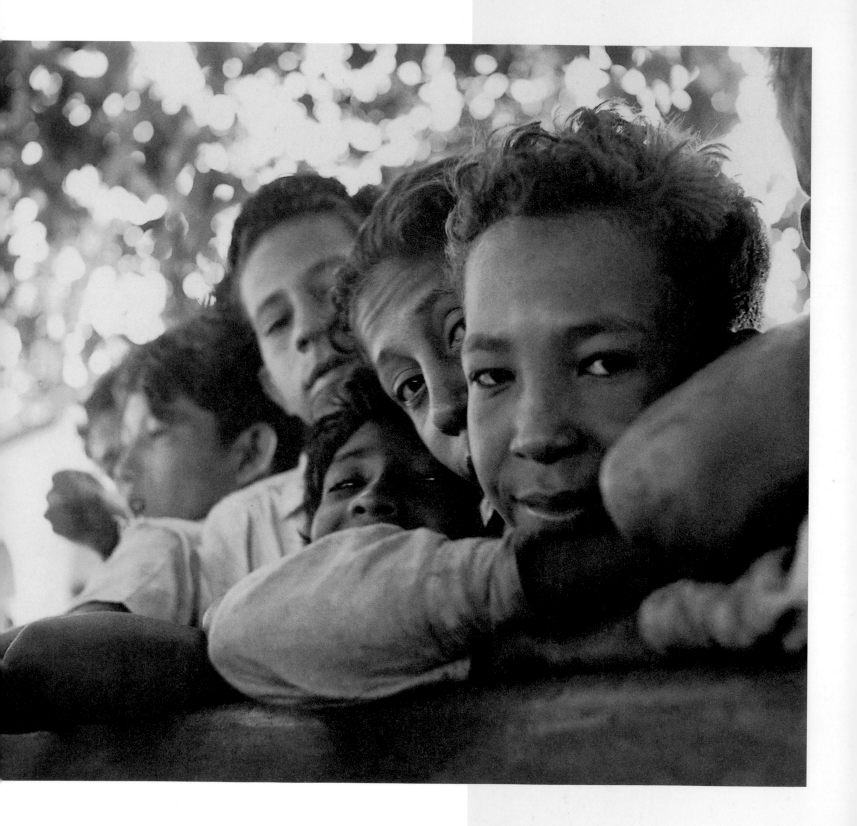

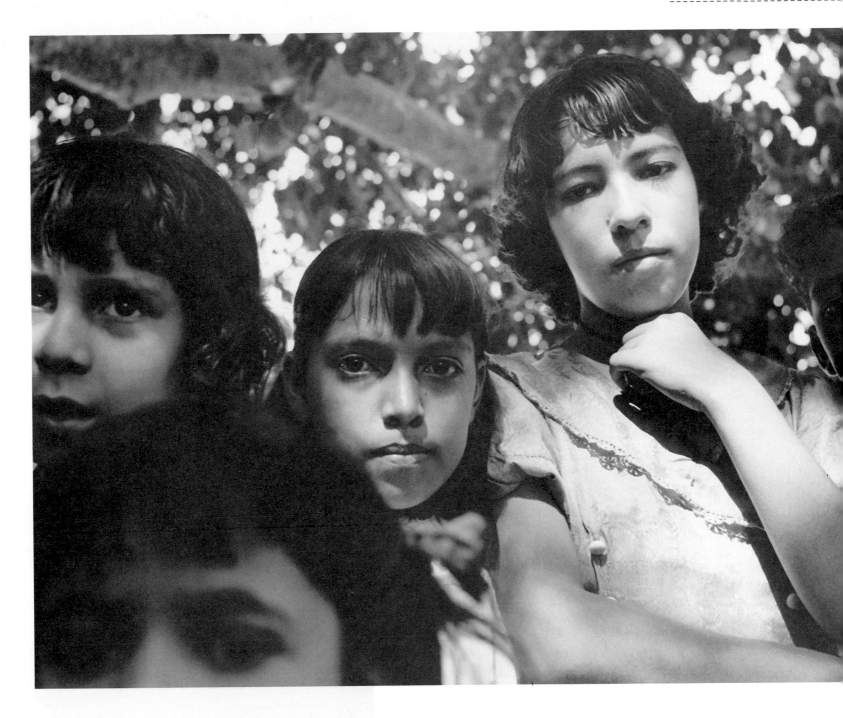

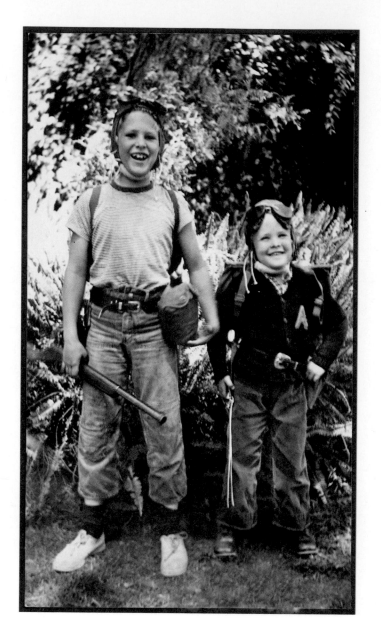

GENERAL OF THE ARMY, OMAR N. BRADLEY

This is a picture I took of my favorite subject, my two grandsons, Henry S. Beukema Jr. and his brother, Omar B. I am afraid that there is no way to explain the taste in uniforms they are wearing. We took them to one of those surplus stores in Los Angeles and let them pick out what they wanted. Then the guns were added from their rather large collection. I am mainly interested in photography because it furnishes lasting records of people and events which can be enjoyed indefinitely. For example, I have some snapshots which I took on the Mexican border in 1916. I have subsequently had many moments of pleasure and satisfaction from looking at these pictures during the intervening years. They recall happily to one's self and one's friends people and incidents that might otherwise be forgotten.

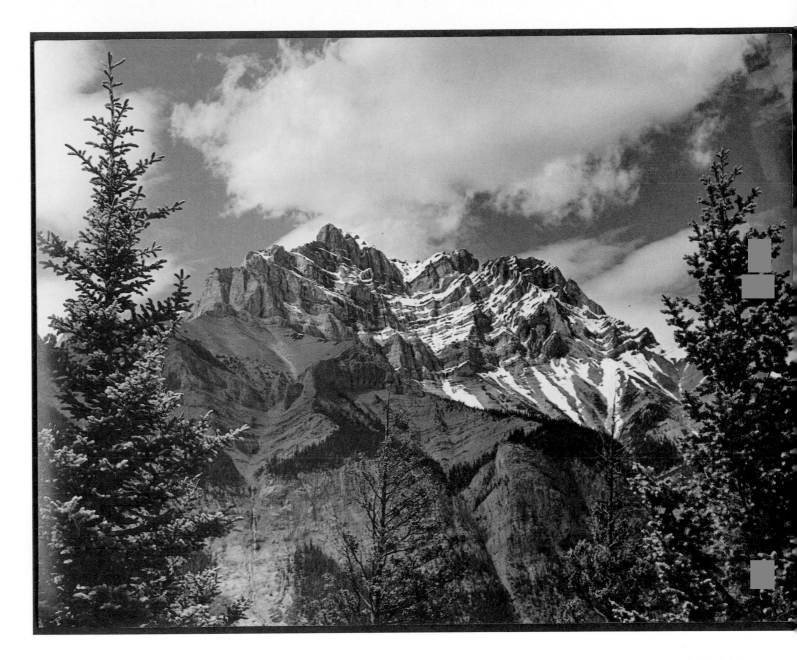

ROBERT STACK

This is my favorite picture of all the pictures I've made, because it has a three-dimensional quality and I don't tire of looking at it. It was made in 1953, Banff, Canada. The camera was a Hasselblad, the film Super XX, and a K2 filter was used.

YEHUDI MENUHIN

Murren, Switzerland, 1945.

On reflecting on my feelings toward taking photographs, I would say that it is the quickest and easiest way of being an artist accidentally; and after playing the violin, the cool, sharp, mechanical click of the camera, carrying the automatic assurance of an emotion or scene trapped, gives a wondrous sensation of relaxation together with finality.

(Mrs. Menuhin confides, "I can say anything I please to Yehudi about his music but I wouldn't dare criticize his photography.")

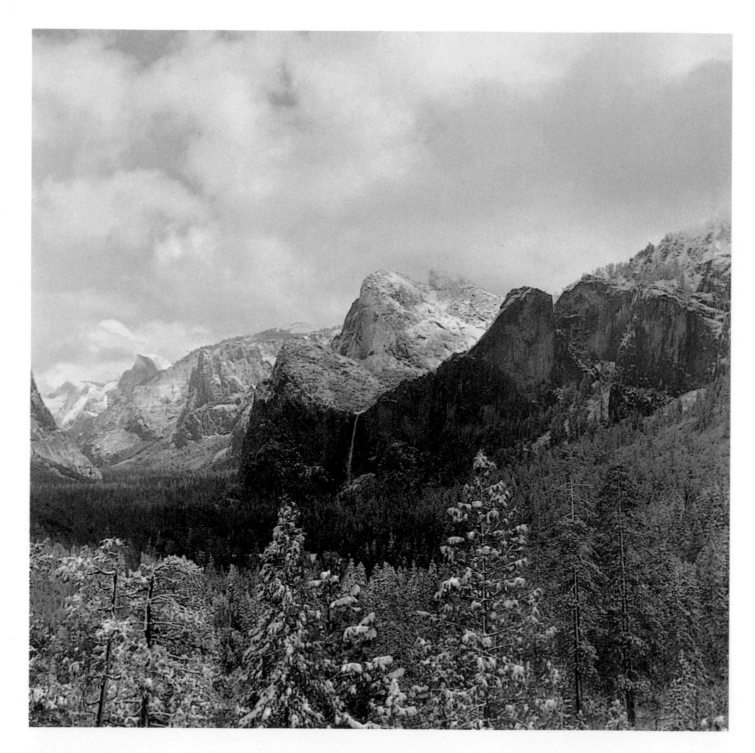

LAWSON LITTLE

Down through the years I was one of the most active amateur photographers on the professional golfing circuit. But a serious fire last April leveled our garage and destroyed my complete file of negatives and pictures. Fortunately, these pictures were in the house at the time. I took them from Inspiration Point in Yosemite Valley, using my Rollieflex with a medium yellow filter. The view from here, I think, is one of the most striking I have ever seen. I enjoy photography as a hobby and feel that the making of a good picture is a personal accomplishment.

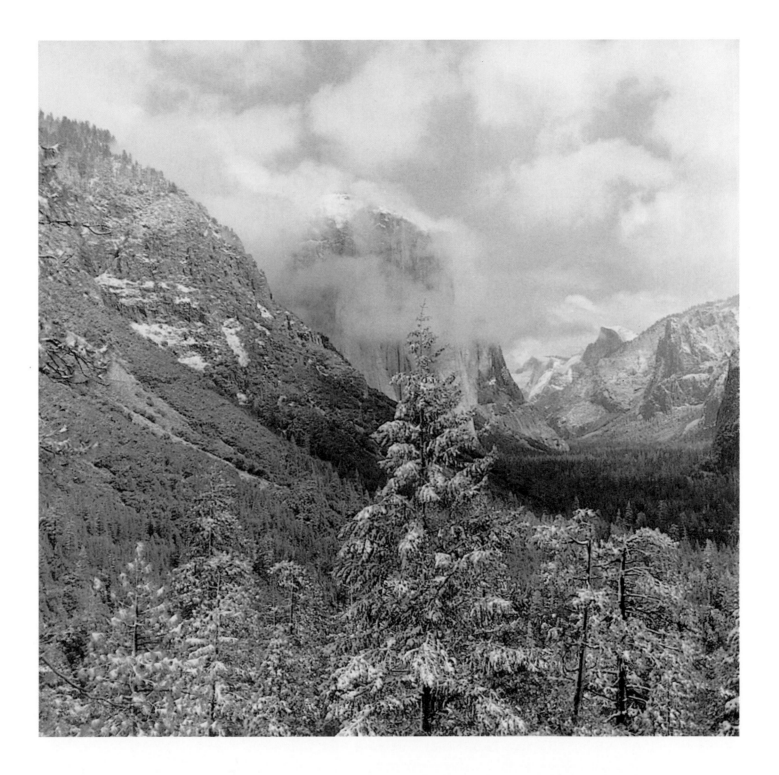

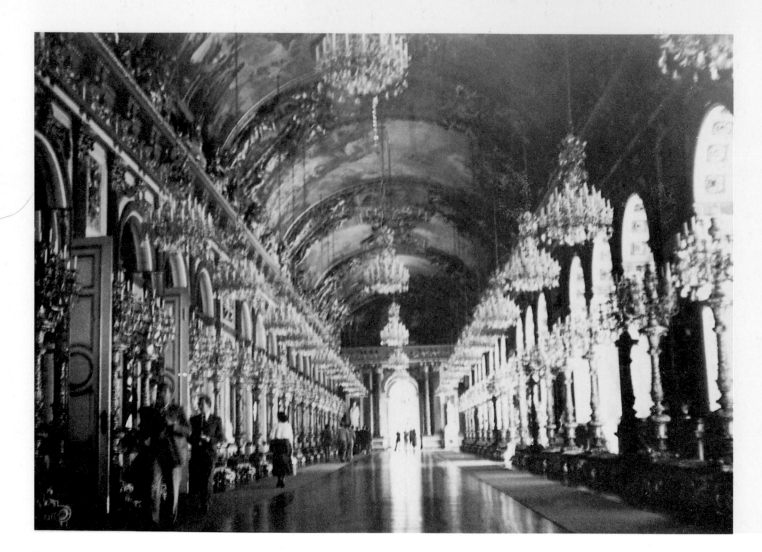

ERNEST BORGNINE

This is not the Hall of Mirrors in the Palace at Versailles. It is a replica, the Palace of King Ludwig of Bavaria, on Lake Chiemsee. I shot the picture with my Rollie—a hundred at three-five—and was lucky to have it turn out so well, lucky because I just happened to arrive at the time of day when the light was just right. I was traveling through Bavaria on the way to Copenhagen to play Hamlet, as a member of the first company to do the play in its original setting. Photography is not a passion with me, but I do shoot pictures at all the locations I visit making films. I file them away, and hope that in later life I can look at them and enjoy all the experiences all over again.

This is the boat harbor in Biarritz. I loved the twisted trees and took this picture because the whole scene looked like a painting. As I recall my history, Napoleon was responsible for a good deal of the construction here and had great ideas for Biarritz, ideas which I don't think ever came off successfully.

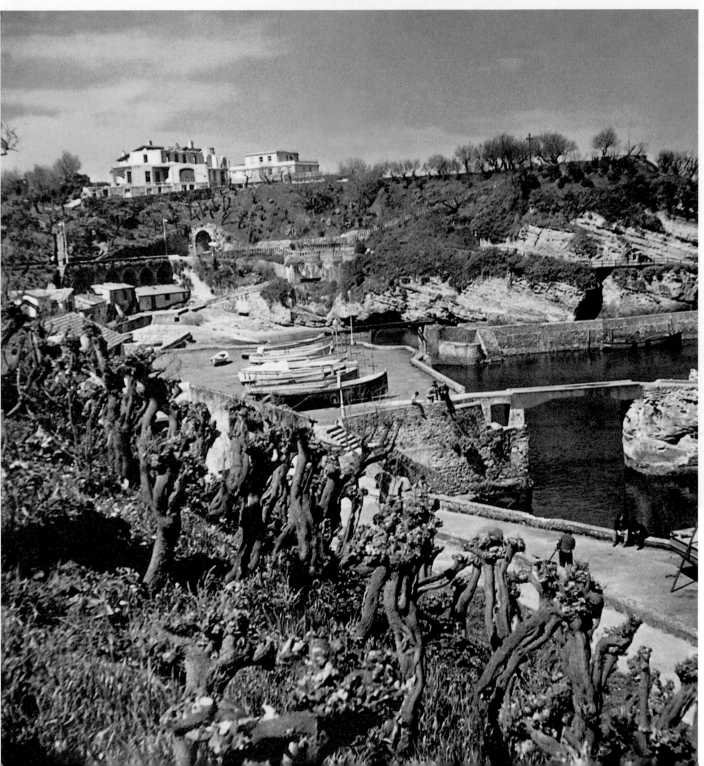

ADLAI E. STEVENSON

I am only an occasional cameraman and
when I do shoot pictures, they are usually
of persons and places especially dear to
me. This one is of the yard of my home in
the country, a quiet place where I have
done a lot of my resting and writing and
thinking.

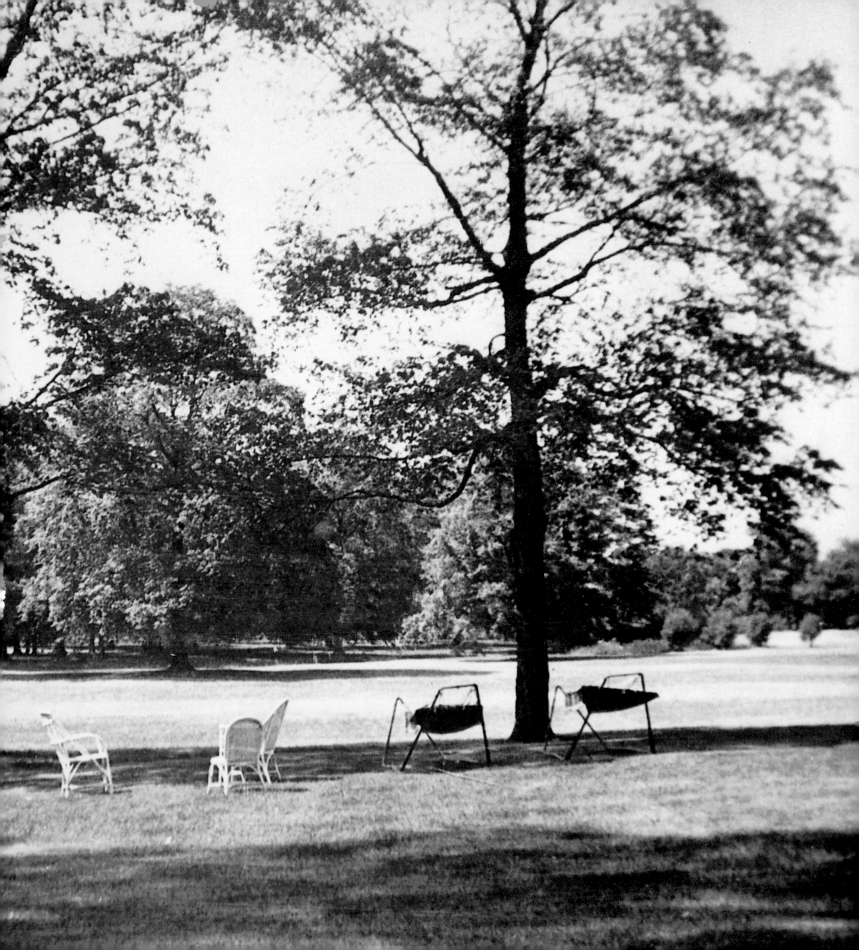

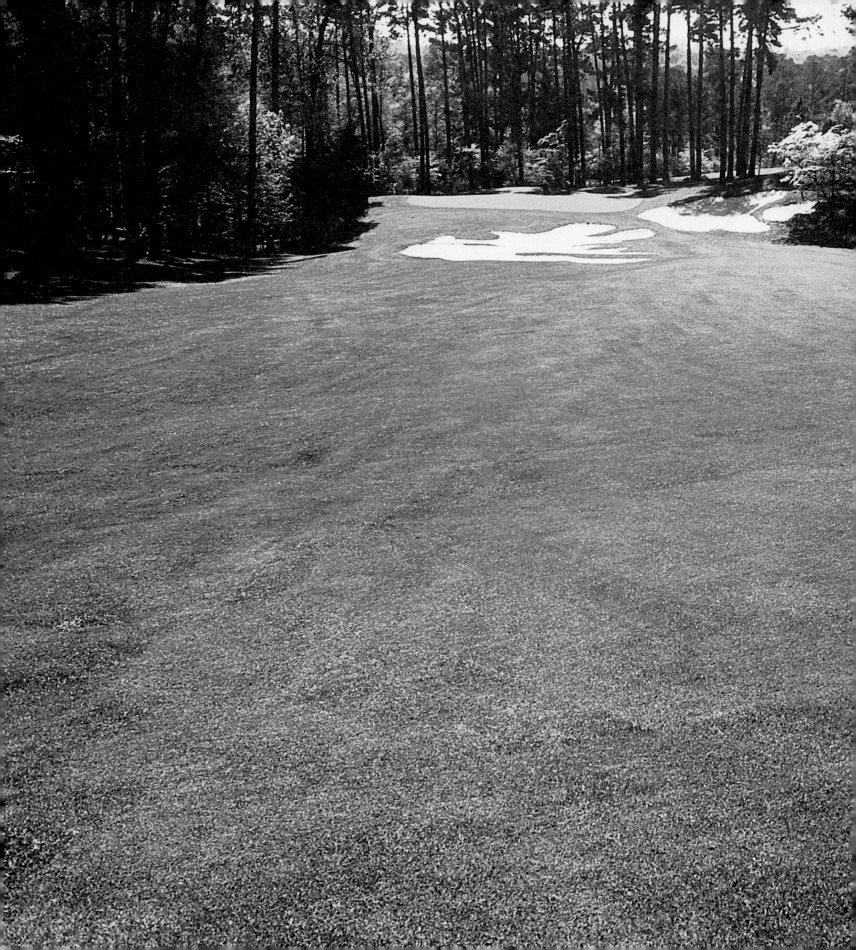

BOBBY JONES

In the course of my lifetime, I have embraced many hobbies, but none of them seem to last very long. I haven't made a picture now in over 15 years and have found that almost all I had have disappeared. This is representative of my efforts in photography, and I made it with my Leica along about 1934 to 1937. The golf course picture is of the 10th hole at the Augusta National, and I like it simply because I think this is one of the most beautiful and testing holes I have ever seen.

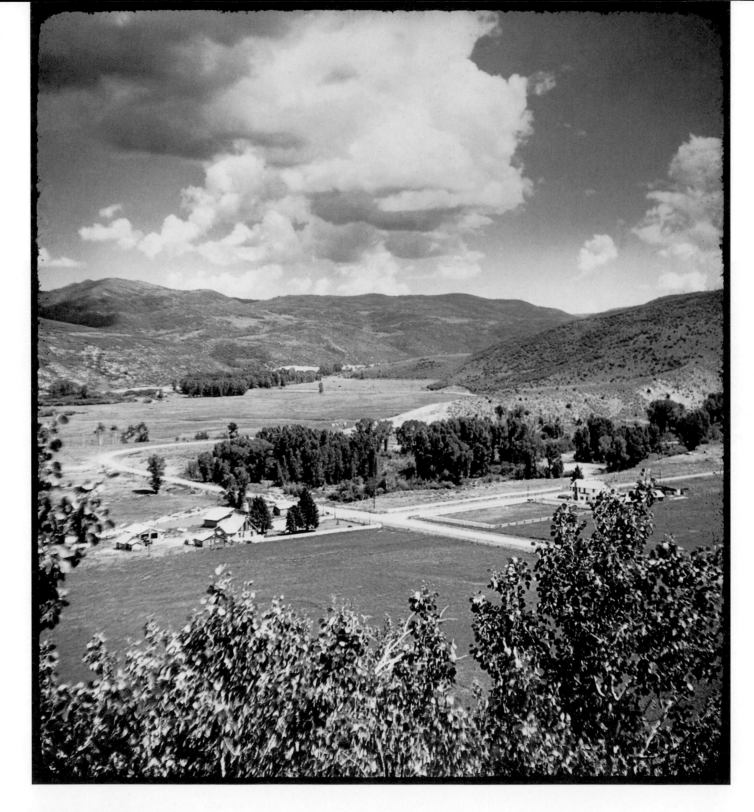

ELEANOR ROOSEVELT

I took this picture of my son's ranch near Meeker, Colorado, because the view was so lovely. What pictures I do make, I make because I just like a record of people and places, but I do rather little photography myself because my friends are so much better than I am.

SENATOR BARRY GOLDWATER

I started taking photographs in the late 1920s because
I wanted to remember Arizona the way it was.

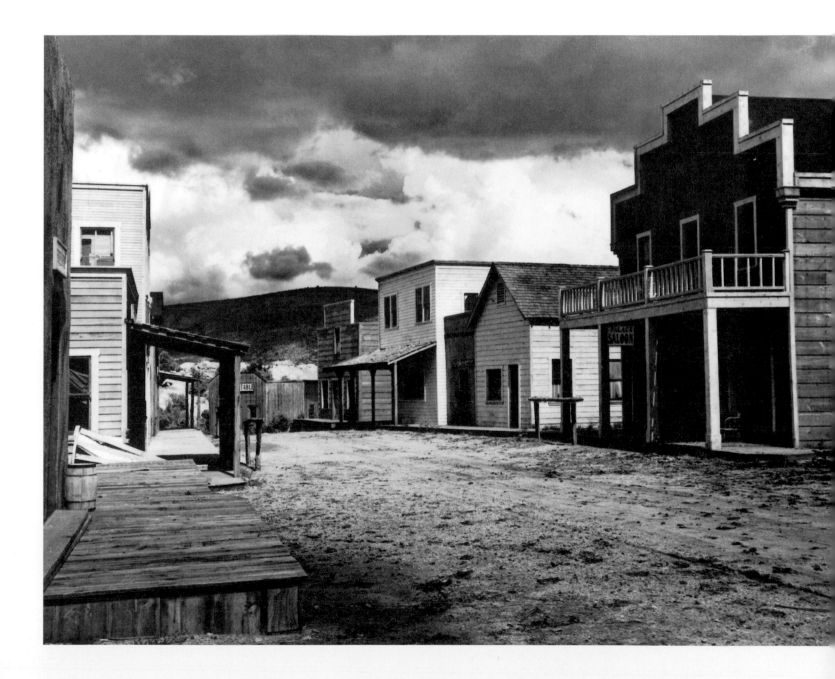

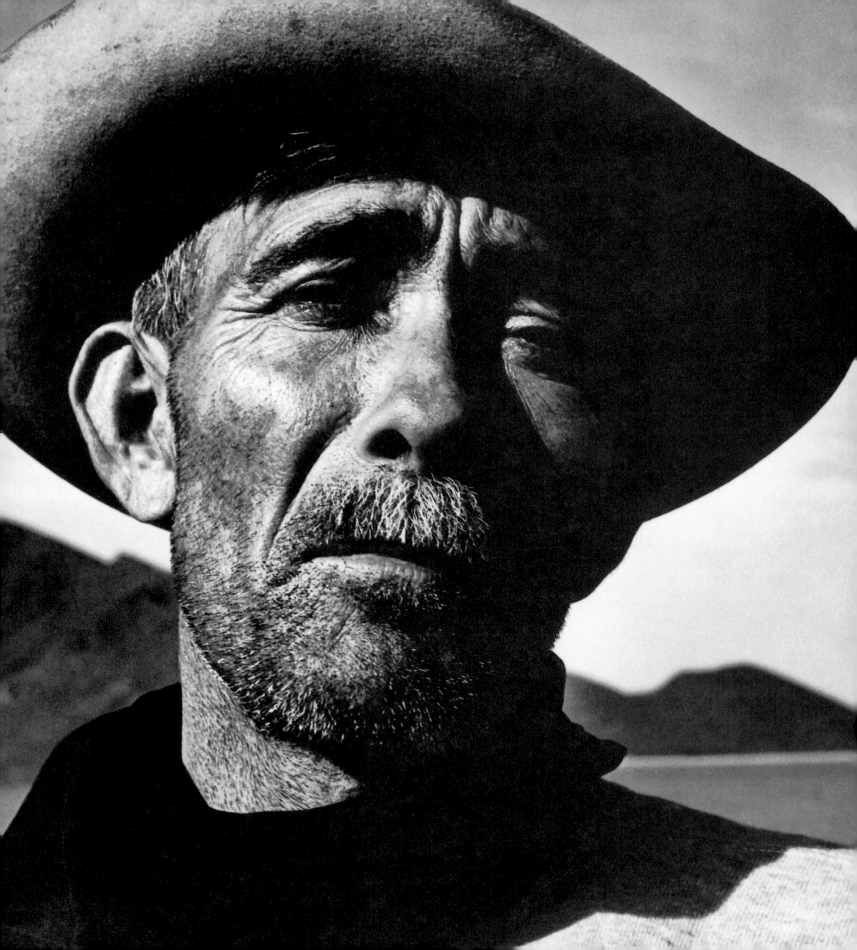

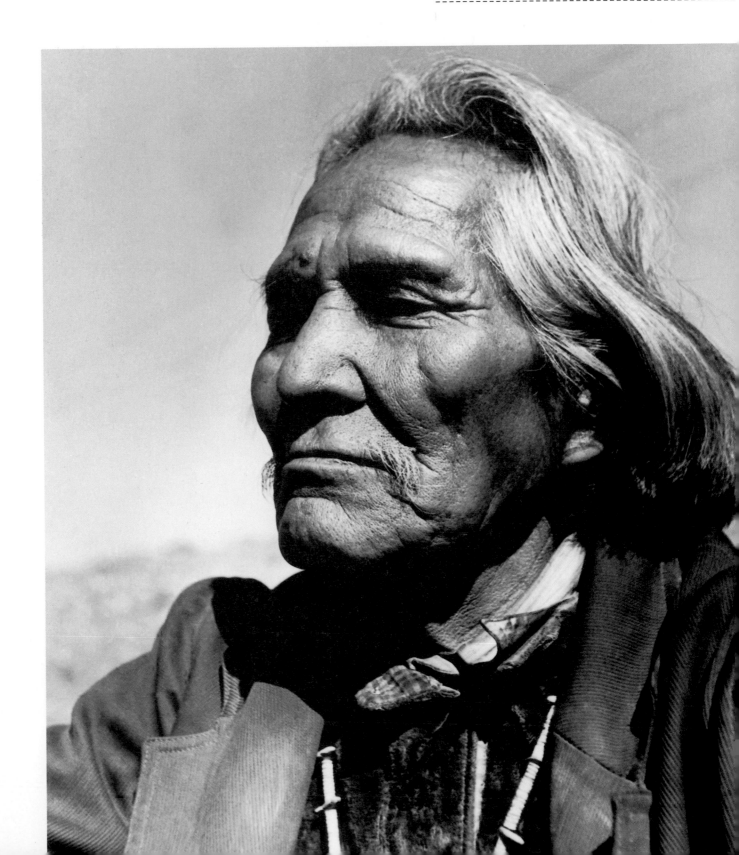

I use my Canon and my Retina IIIc cameras as a notebook. I find them very useful in this regard, for the relatively low cost of film and its universal availability enable me to record a great deal.

Like all Americans in Thailand, I have been much impressed by Buddhism. I became rather good friends with the delightful Buddhist monk (opposite) and enjoyed his reaction to life. If I remember correctly, he had ducked into a monastery for a three-month period seeking refuge from a bill collector. The simpleness of such a religion impressed me deeply.

Once, in writing of Japan, I used the phrase, "In Japan, even the dead are crowded." This phrase derived from the picture below of crowded gravestones.

Like most men I love to tinker with machinery and, not having a woodworking shop, I find a camera just about as compact and complex a gadget as I require. I have worked out tables for auxiliary lenses, extension tubes, and microphotography, which permitted me to get some pretty good results. Thus I look on a camera almost exactly as a teenage boy looks on a jalopy.

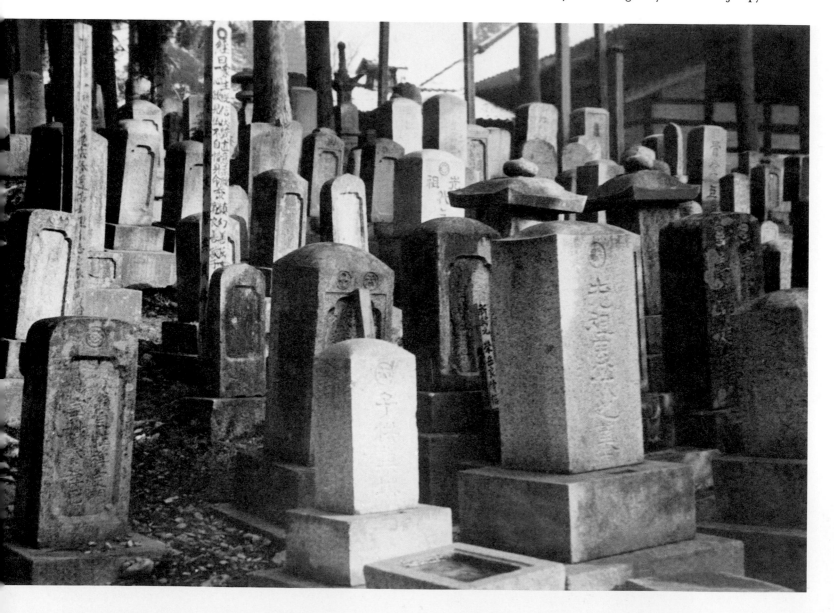

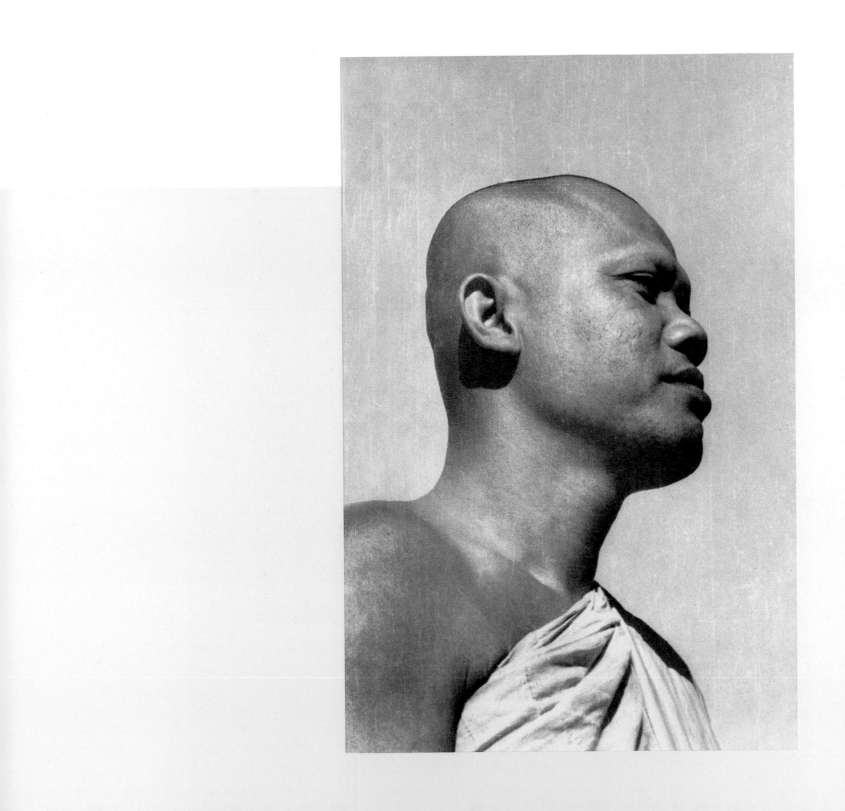

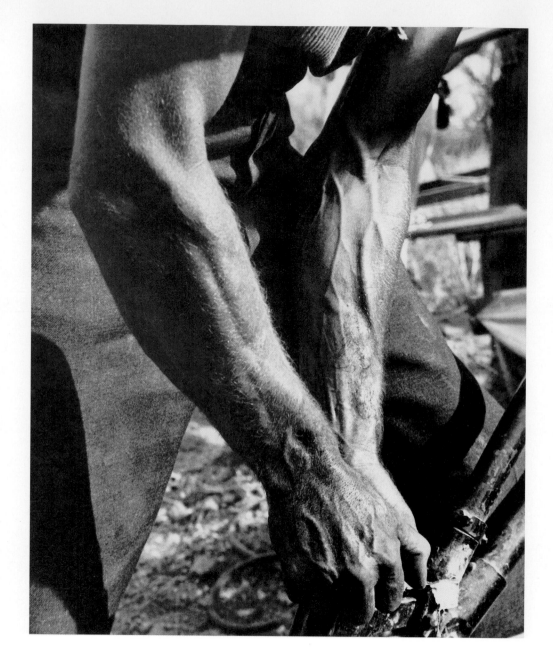

ROUBEN MAMOULIAN

Moments of life, which pass away and may at best remain as faint echoes in one's memory, can be arrested and preserved by a snapshot. Photography performs the miracle of making the fleeting permanent. My main interest in photography lies in seeing a familiar object in an unfamiliar way, thus giving it a new eloquence. Also, in presenting an everyday thing or occurrence which one usually takes for granted in a way that turns it into a symbol. A perfect example of that is the photograph of the two arms: this one moment of activity captured into permanence becomes to me a symbol, a noble symbol, of Man's Labor.

The bridge is one of a series of snapshots I took of the Brooklyn Bridge. I was fascinated by the many various moods one can discover in this structure of steel and wire, depending on the light, angle, and composition. This particular picture expresses to me a serene orderliness, harmony, and beauty of man's achievement.

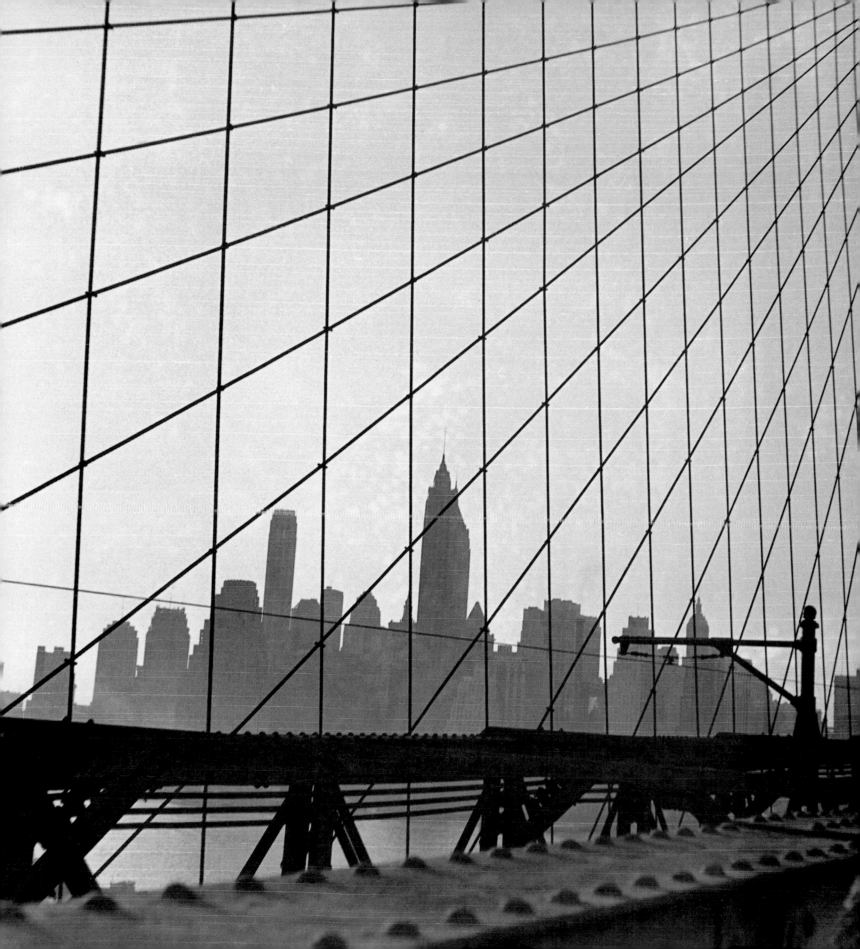

I became seriously interested in photography in the early days of World War II when I covered the evacuation of Burma and the bombing of China by the Japanese. The shot of the Chinese people fleeing the Japanese attack on Chungking in 1941 was taken on assignment from *Life*, though I always considered myself an amateur photographer. Many years later, the floods of 1955 in Connecticut ruined my files of prints and negatives so little remains of that period. I have since reactivated my interest in photography, as evidenced by the photograph I made on the yacht *Creole*, owned by Stavros Niarchos (opposite).

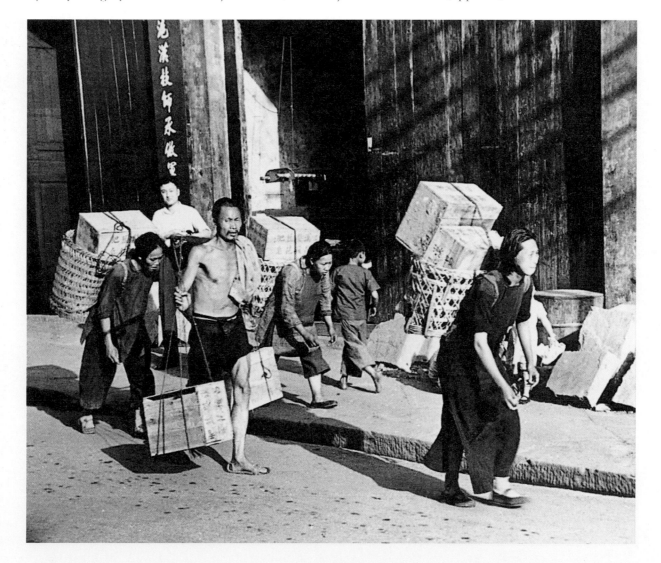

ALFRED HITCHCOCK

I am strictly a professional and an amateur. In my work, the approach to photography is terribly different—strictly the use of the pictorial for telling the story. The motion picture, literally, comes first; the spoken word is secondary. In terms of amateur photography, my mind is not on it: I shoot pictures merely to recall places we have been, merely to record them but not with any aim of pictorial quality. The tower is part of the Taj Mahal in India. I thought the usual picture of the Taj was obvious and never really impresses with its size because it is always taken from so far away. This is one of the four towers surrounding the Taj and you get an idea of size from the figures near it.

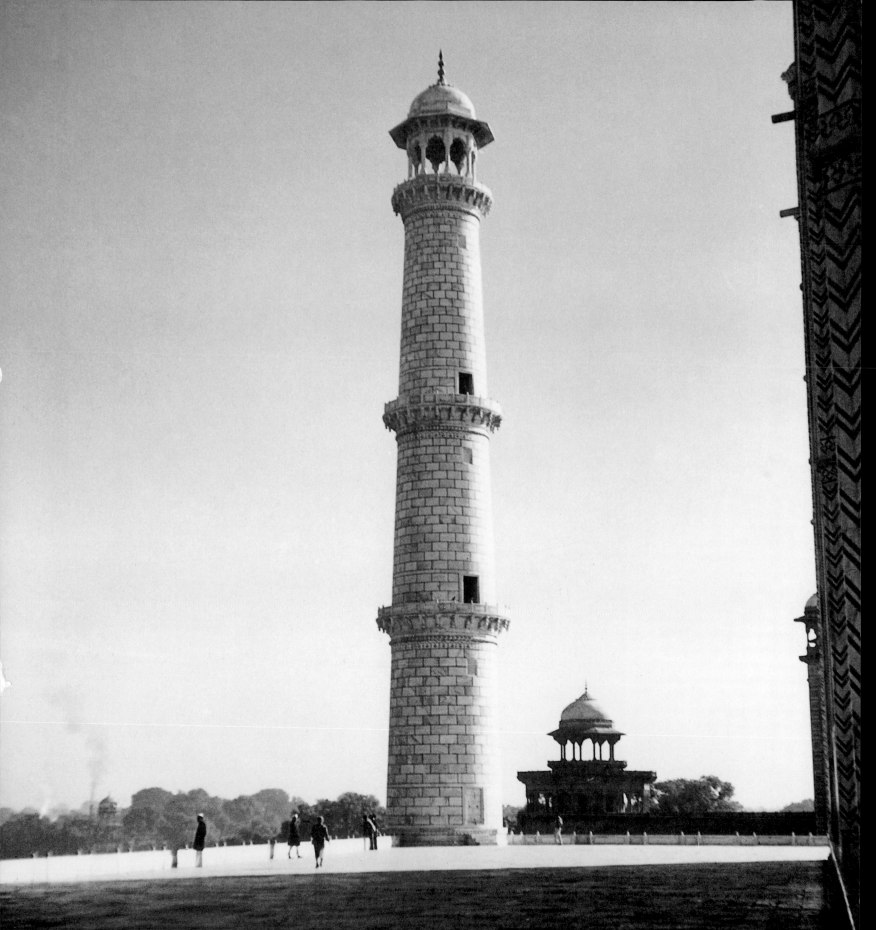

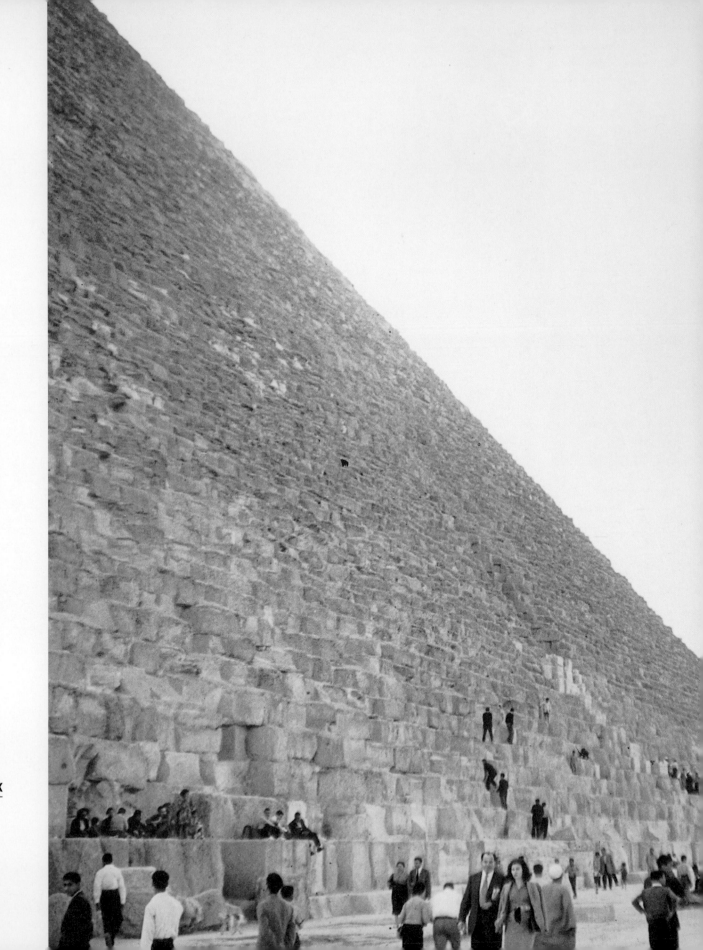

ALFRED
HITCHCOCK

The side of the pyramid is a view of one of the big pyramids of Egypt. What intrigued me the most about this was the fact that you can ride a trolley car right up to the pyramid.

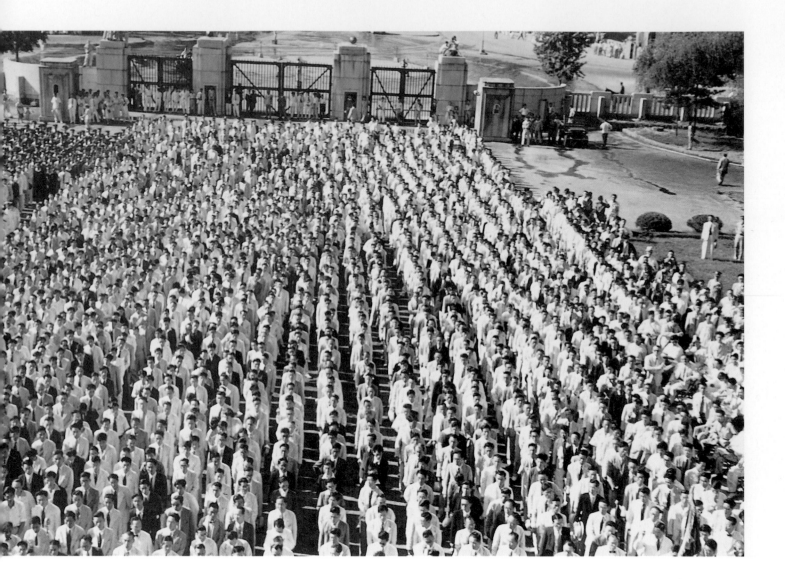

GENERAL WILLIAM F. DEAN

Both of these pictures are good examples of why I take pictures: to record in pictorial form personal experiences and interesting events, to remind myself of things I've seen in the past—things of significance. The picture on the opposite page shows the tidied remains of an armaments plant in Nagasaki as it

appeared long after it was destroyed by our second atomic bombing of Japan. I took the picture in May 1950 with the inexpensive Japanese Konica camera. To me the bomb damage was much more apparent in Nagasaki than Hiroshima. I took the above picture on 15 August 1949. The occasion was the first anniversary

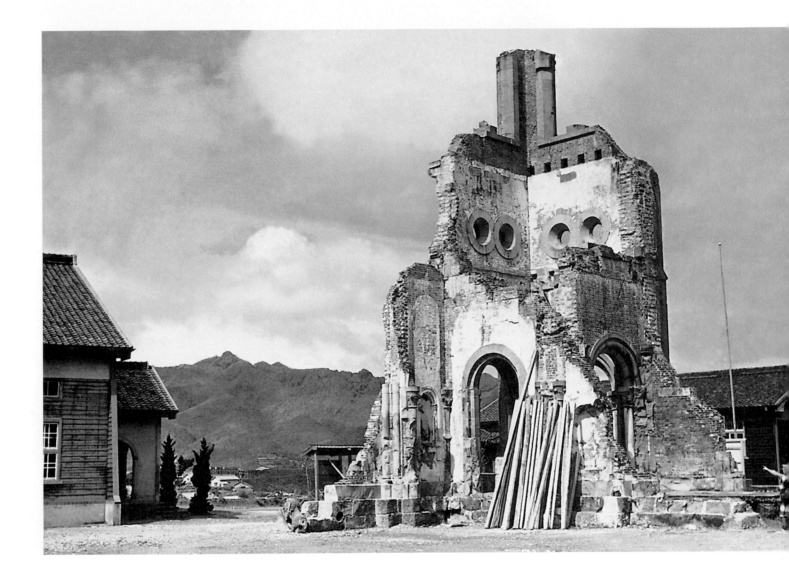

of the Republic of Korea and I had been invited to attend the ceremonies as a former military governor of Korea. Actually, I was our last military governor, having served from 1 November 1947 until the Republic was proclaimed on 15 August 1948. I took the picture from the speakers platform, and though it was one of the hottest days I experienced in Korea, the citizens lined up in the neat columns you see in the picture and stood for hours listening to the speeches. The gates in the background are in front of the capitol in Seoul.

I shot the Plaza San Marco in Venice (opposite) because I was fascinated by the marvelous pattern formed by the symmetrical arrangement of the tables and chairs. This picture also shows how certain areas are completely deserted during siesta time. I shot the mother and child below in Korea. Her face shows tremendous hardship, and she's only about 30 years old.

I use a Stereo-Realist for color; I shoot my black and white with a Nikon. The Chinese say one picture is worth a thousand words, but I feel a picture goes beyond that—it includes smells, words, and sounds. When I look at an old photograph, they all come back.

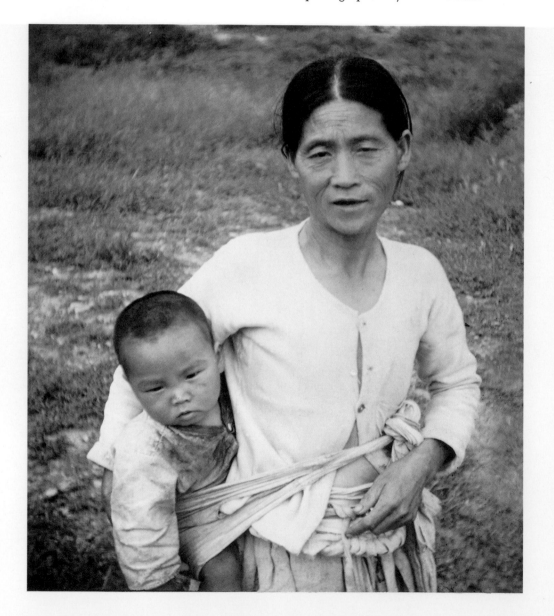

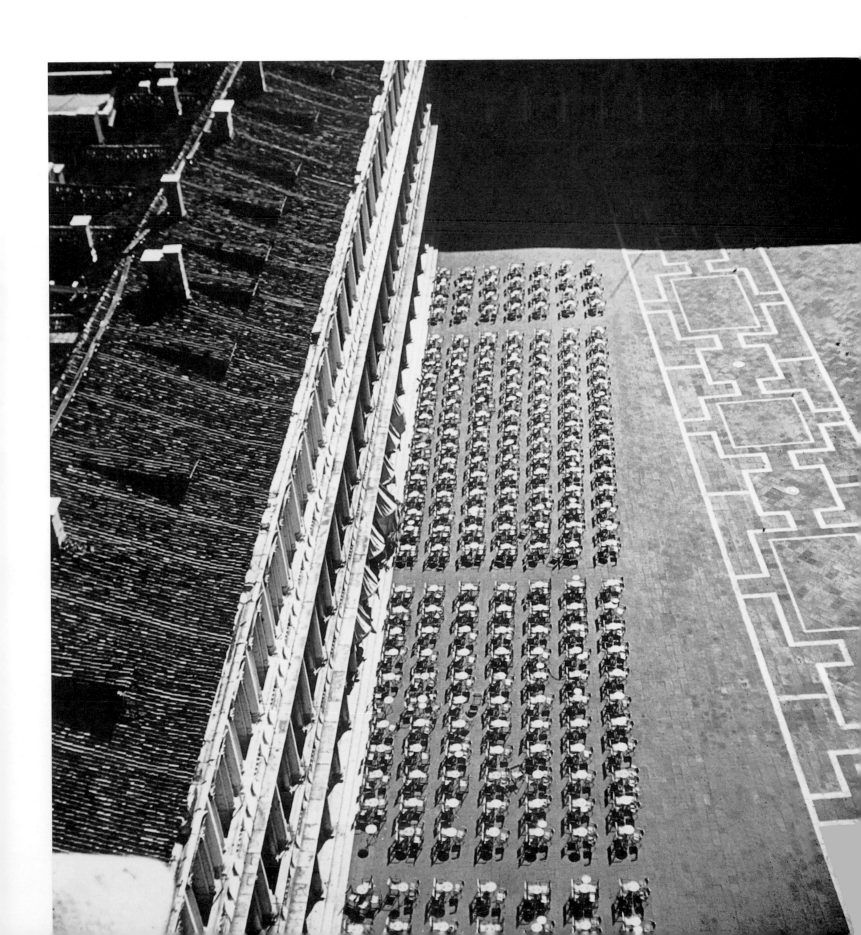

I feel that no matter where one went in the world, it would be difficult to find a face like that of the old Hakka fisherwoman I found at Deep Water Bay in Hong Kong. I deliberately photographed her late in the afternoon when the light source was low and her wrinkles and the details of her face would show. Her face has age; it tells the story of the hard life lived by these primitive Chinese in the Islands, yet it has humor and a sense of the ridiculous about it.

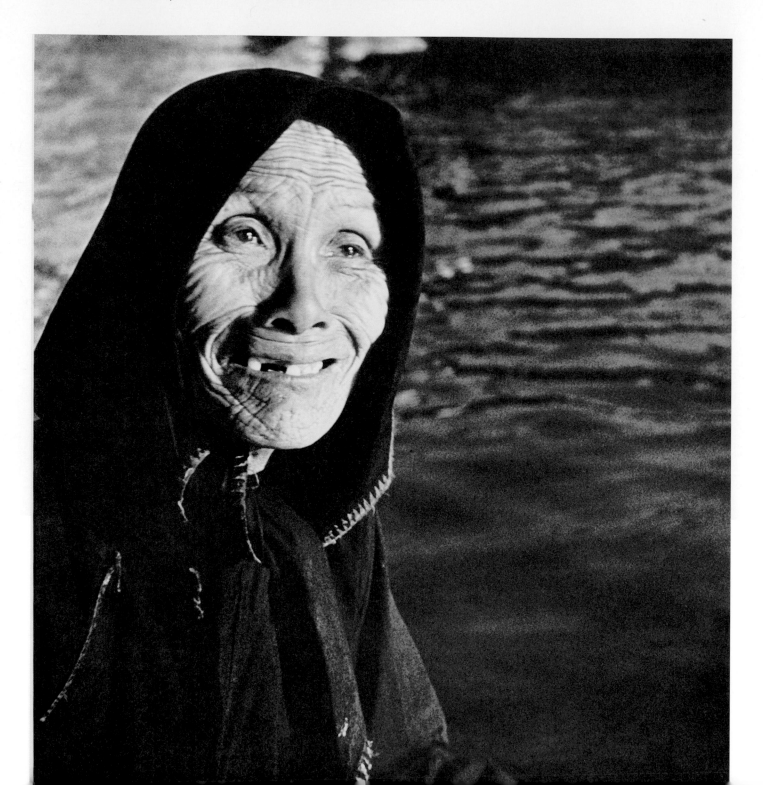

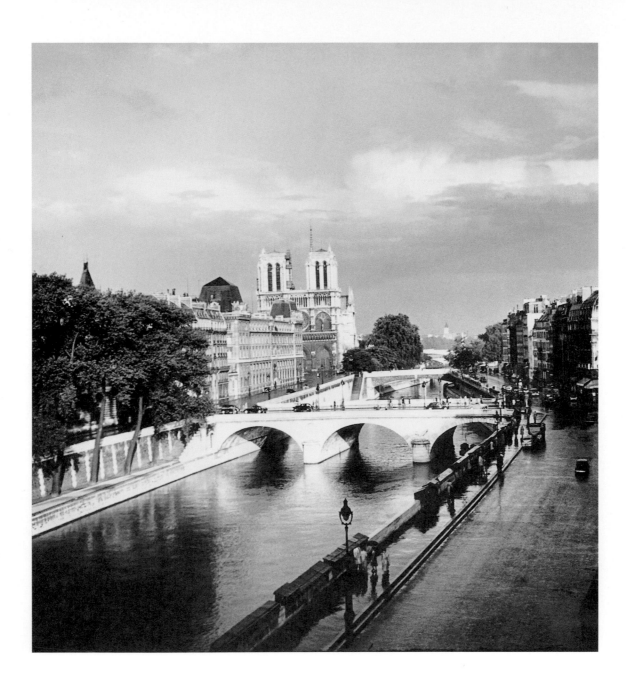

DAVE GARROWAY

I chose this picture as my favorite because it is the solid groundwork of France, the real France that lies beneath the daily change of Cabinets. I took it from the window of the Hotel Bisson in 1951, and the camera was a Stereo-Realist. I think it is a handsome view of the River Seine, its sidewalk book stands, its handsome bridges, and the redoubtable Cathedral of Notre Dame.

The "Roofs" of the San Marco Cathedral in Venice (below) is a particular favorite because of the tensions and kinetic forces of the picture by the changes of direction in every dimension of the roof's patterns. It has the surface of a modern painting, and the viewer's eye is pulled into the picture and led through these tensions up, down, in, out, and across. My favorite portion is the lower right corner, which suddenly plunges down into a courtyard, while the upper left-hand corner bulges up and out in a dome. Then there is the punctuation of the black arches and pointed spires.

"Sneedens Landing" (right) has no special darkroom work except I printed it lighter as I didn't want the sky to get too dark grey. It was a foggy day, and the picture is about how I saw it.

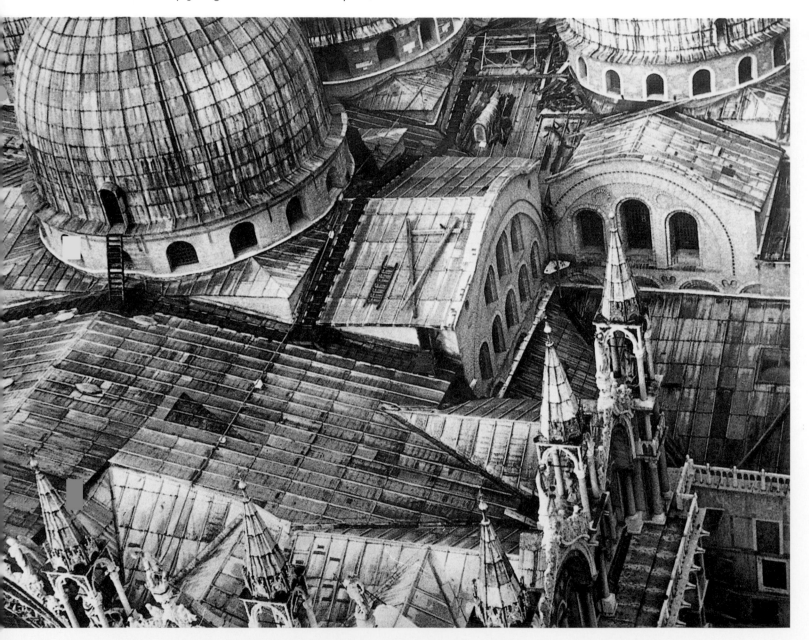

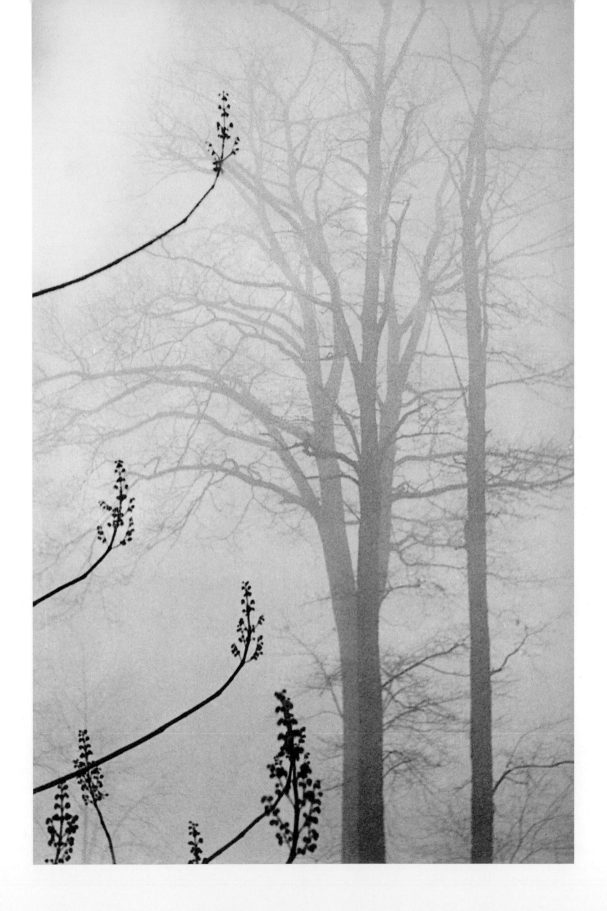

JEROME ROBBINS

"Tanny" is a portrait of a friend I love dearly, Tanaquil LeClercq, and it was taken last spring after she returned from Copenhagen. I took it outdoors on the terrace of a hospital. I used a Rollieflex and took a waist shot, shooting into a shadow with dim light coming between two buildings. I love the picture because her beauty, wit, tenderness, sensitivity, courage, and directness are all reflected. The large luminous eyes are haunting, and the contour and proportion of the face are very appealing.

The appeal of the "Grill," which I shot in Verona, Italy, in 1951, also with the Leica, is its wonderful all-over design. It works because it is not symmetrical, and although the eye doesn't catch it immediately, some of the designs have pieces missing, and the combination of crudity and elegance of the wrought iron grill is apparent. The black-and-white stripes of the church in the background, punctuated by the two windows, increase the asymmetry so that the eye never gets tired.

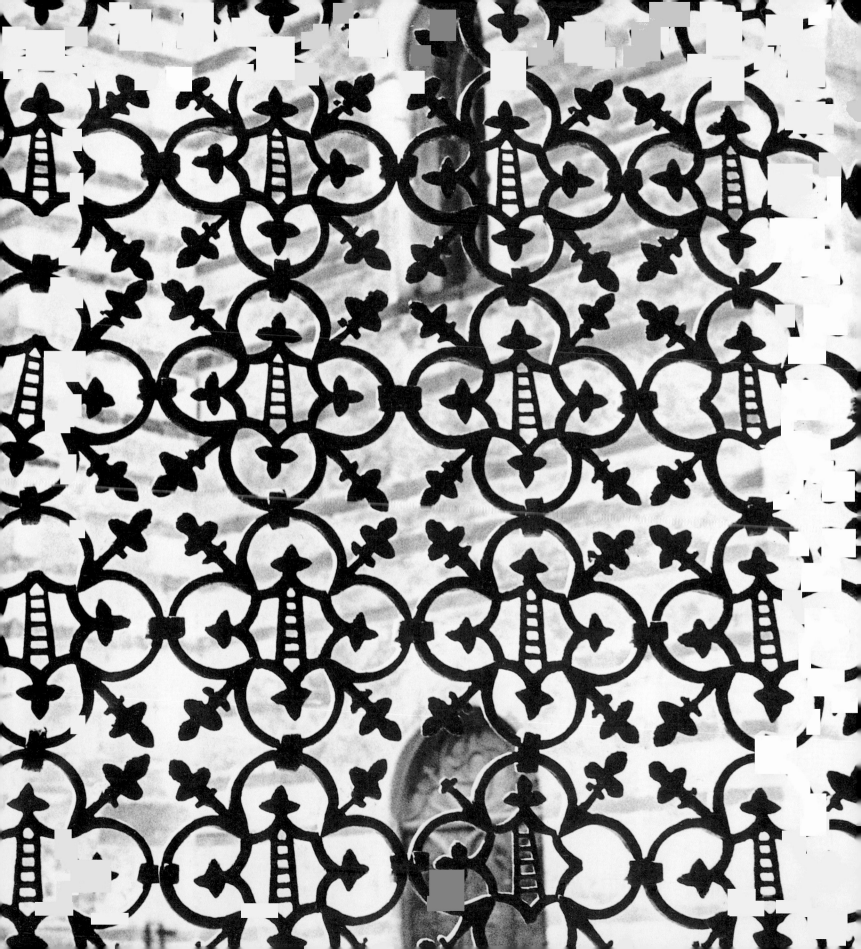

Composition and the fixing permanently of experience and an atmosphere attract me to photography. Particularly enjoyable to me is the darkroom work, which I guess is an antidote to my professional work in the theater. The quiet, the solitude, the freedom from pressure, and the freedom of time to create, select, reject, experiment, and begin all over again make the art of photography most enjoyable to me. I'm mainly interested in black-and-white pictures rather than color, and photographing friends, places, and children.

I photographed the clown with a Leica and telephoto lens during the stay of the circus in Madison Square Garden, shooting from the ring itself. The clown wearing a mask presents the mysterious play between caricature and reality, fear and gaiety that a circus clown provokes in a spectator.

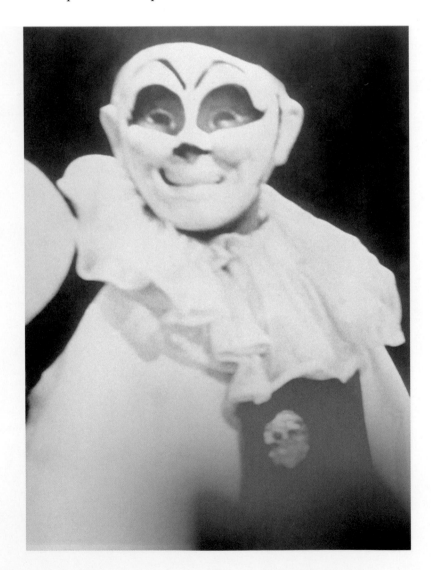

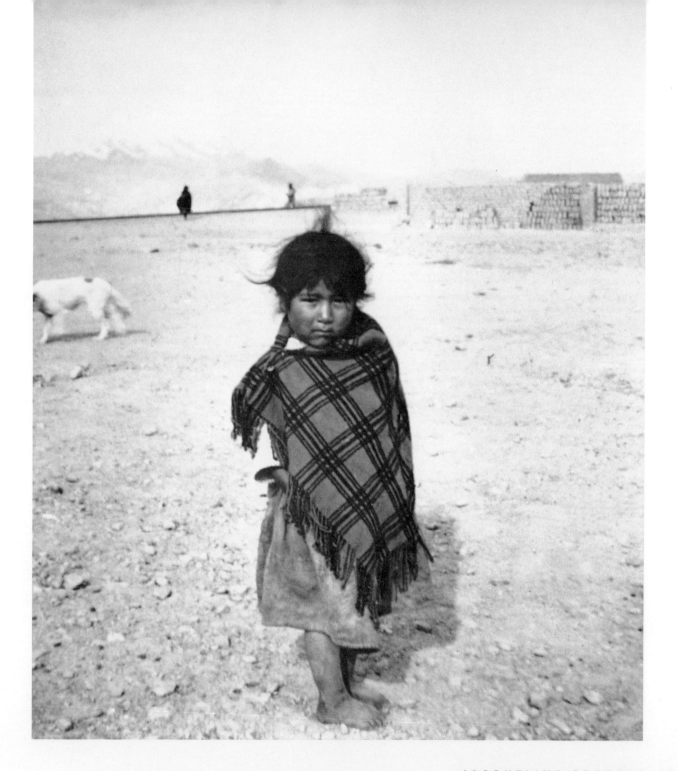

JACQUELINE COCHRAN ODLUM

I take pictures only when a subject is really unusual and holds special appeal for me. In this case, I was moved to photograph this little Bolivian girl because she gave such an expression of composure and dignity in spite of her poverty. I took it in June 1953 with a Stereo camera at an altitude of 15,000 feet near the famous Bolivian ski run, Chacaltaya.

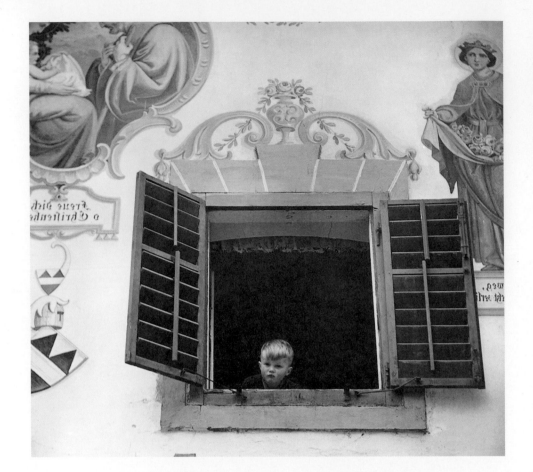

JOHN WAYNE

Wherever I go on my travels to the many out-of-the-way places my work takes me, my camera, or rather cameras, are as much a part of my personal baggage as my toothbrush. With the ever-present thought in mind, "I may never pass this way again," I try to record the moments that have pleased, interested, or excited me. The photo of the little boy in the window pleased me both because of his expression and the interesting frescoes surrounding the window: typical house decoration in the tiny hamlet of Itter, Austria. Faces of children always interest me, and I never tire of photographing them. I was fascinated with and photographed the little girl in Kitzbuhel, Austria, and as I did so, I thought her wonderful expression could belong to any child any place in the western world.

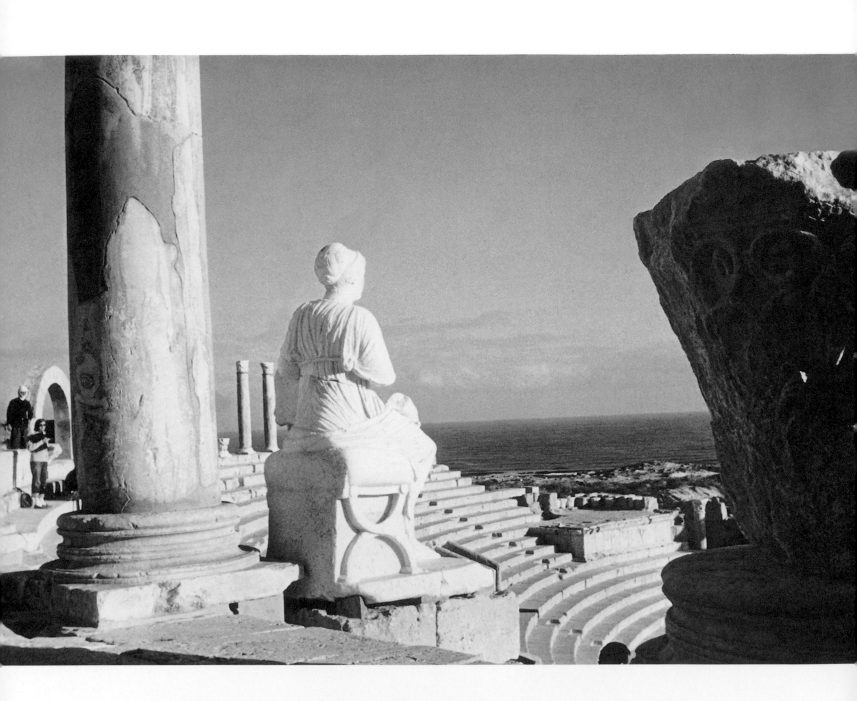

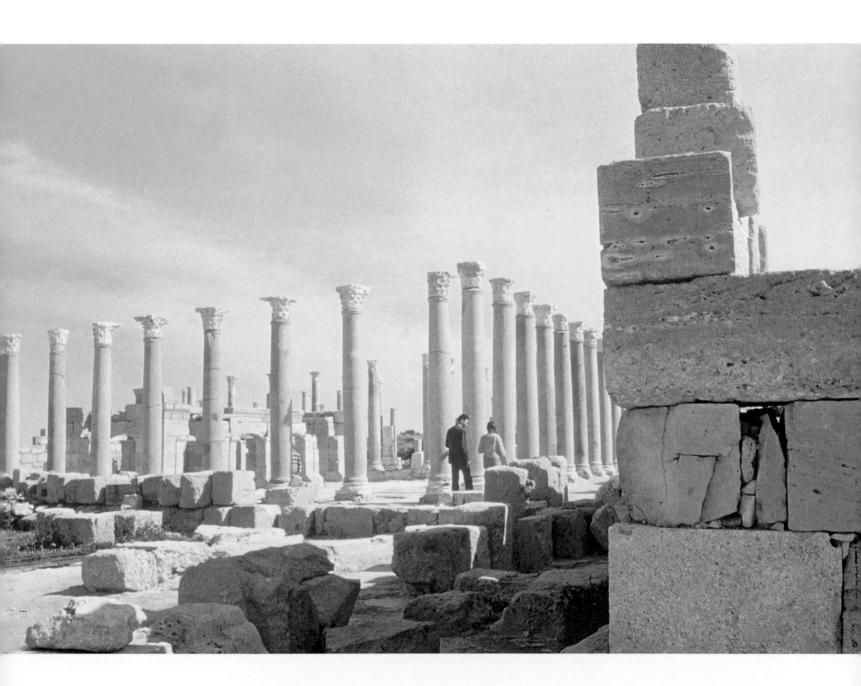

JOHN WAYNE

For excitement, the beauty and antiquity in the photo of the ruined Roman city of Leptis Magna on the shore of the Mediterranean in Libya speaks for itself. Down through the years I ran the gamut of cameras of different sizes but finally settled on a 35mm. A few years ago, I came into possession of a Nikon and I like it so well that when I came to Japan for my latest picture, I traded my other 35s in and now have three Nikons with all the lenses.

147

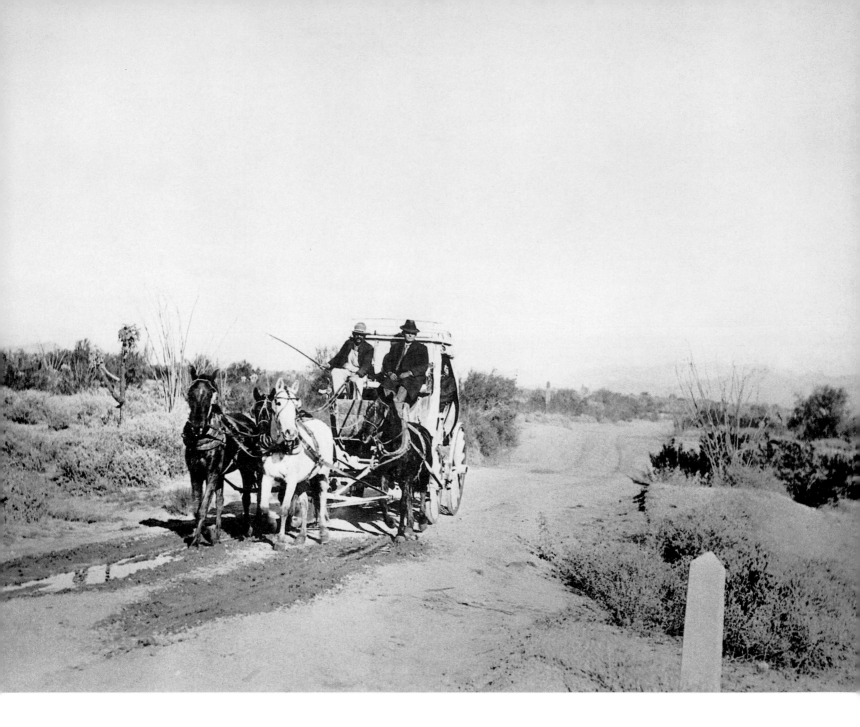

SENATOR LEVERETT SALTONSTALL

This is a snapshot I took in the winter of 1910, when I was at a school in Mesa, Arizona. It shows the Roosevelt stage, which covered the 80 miles between Mesa and Roosevelt daily, changing horses four times. I have not taken many pictures in recent years for various reasons. When I looked through my album, I thought this was quite an appropriate picture, in view of the times then and the times now. As you know, the Roosevelt Dam on the Salt River, which was named after President Theodore Roosevelt, was then under construction. See in the foreground a milestone. I don't know which one.

I took the group by the cart in Killarney on a Fair Day. I was interested in it, as to me there was something absolutely James Joyce in this moment.

I think photography should be a part of everyone's life. I have scrapbooks of photographs I have taken of my children when they were eight hours old, as well as every year after. I love taking my Leica to parties my children go to and capturing their activities, as well as photographing my friends and places I travel to. My equipment is simple: one Leica camera.

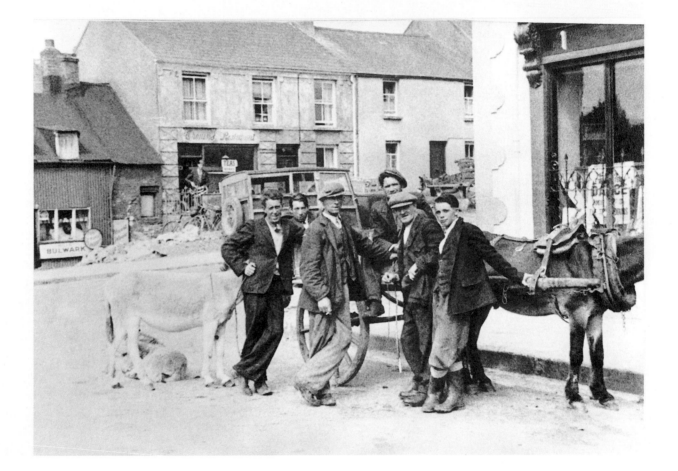

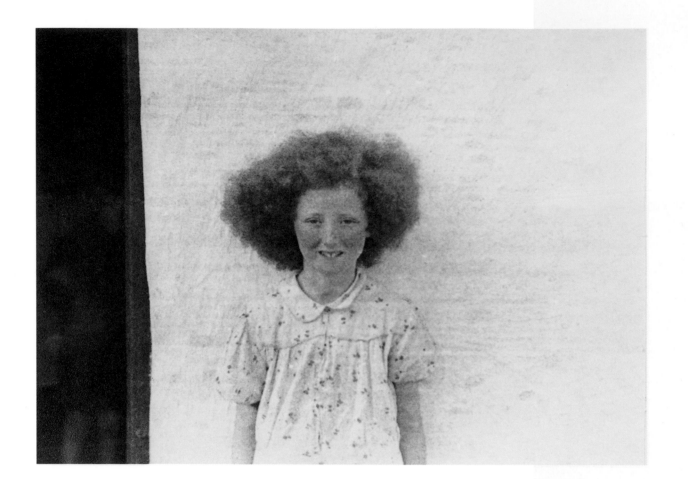

GLORIA VANDERBILT

I took the picture of the Irish girl one summer when I drove down the west coast of Ireland. Suddenly, far ahead I saw what I thought to be someone running along holding a lighted torch. It was around five in the afternoon, and in the misty half-light it became even stranger as I drove closer. It was only when I was next to it that I realized it was not a torch, but a little girl with the most flaming, incredible, bushy carrot-colored hair imaginable. She was very shy, but finally her mother, who was delighted, encouraged her to let me take her picture standing by the doorway of their house. My only regret was that I had no color film with me.

The picture to the right is my favorite. It is a photograph of my sons Christopher (in profile) and Stani Stokowski, taken in our living room.

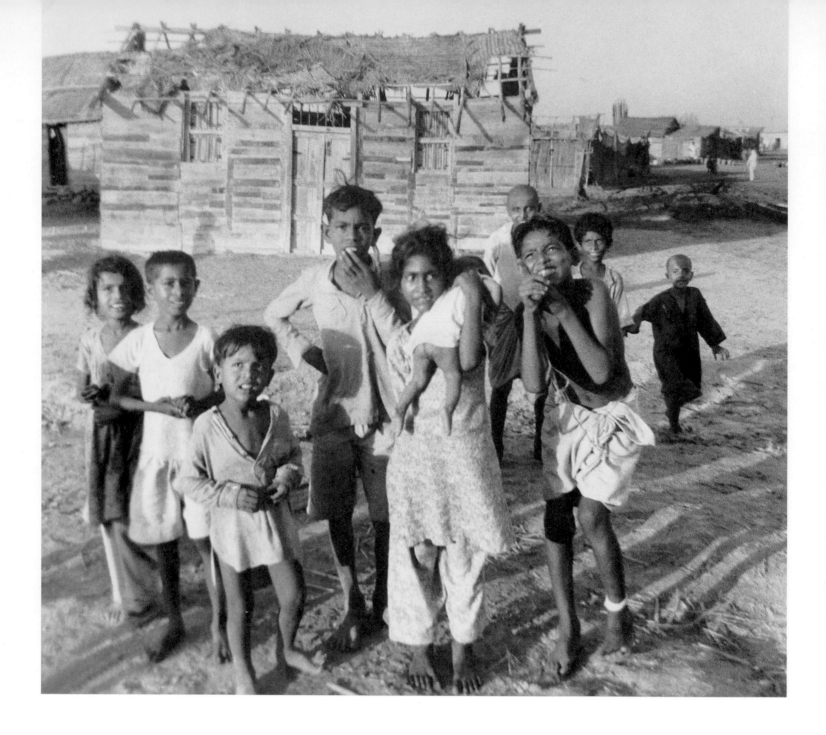

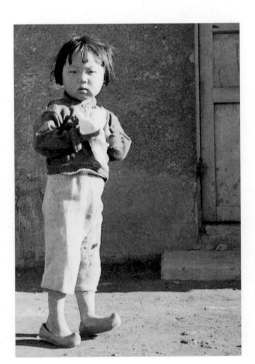

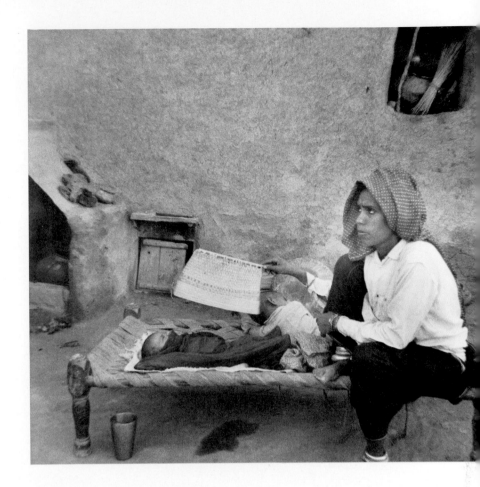

ESTES KEFAUVER

I took these pictures on my long journey through Europe and Asia in 1954. I photographed the round-faced little boy in suburban Seoul, Korea. He had great appeal and I was particularly interested in his wooden shoes. The group opposite was typical of many I encountered in the villages of India. Photography is of great value in that it aids in recalling not only one incident but several, and it also furnishes a permanent record. I have several pictures I took on this trip and they will always be helpful in recalling the events and experiences and the sights that made it so rewarding.

I made the picture of the mother fanning her sick child in the same village. The United States had been giving aid to this area and the child was being attended by an American doctor.

GARY COOPER

Rocky and I have been taking pictures ever since we were married. We shoot and have been shooting on all of our trips—to the Middle East, Europe, Mexico, and throughout the United States. We keep photo albums and are very particular about keeping them up-to-date. We have six large albums with about 500 photographs in each, each picture being a little bit smaller than postcard size, many of them color. We found the little Mexican girl just outside Mexico City. I find the photo interesting because, apart from the melting smile of the little girl, it presents such a contrast. She is wearing the crossed ribosa, and is carrying her younger brother on her back papoose-fashion, in the tradition of her Indian fore-

bears, as they have done since long before Cortez. Yet she is standing there in the unpaved street of an ultra-modern house with an austere, smart white railing fence which is a far cry from the traditional adobe or lava rock walls.

I took the other picture about an hour's ride from Cuernavaca, Mexico, during the shooting of *Garden of Evil*. The canvas had been set up for market day, for protection against the merciless rays of the sun. Those who didn't seek refuge under the canvas went inside the church where it was much cooler. Only the horse did not have enough sense to get in out of the sun.

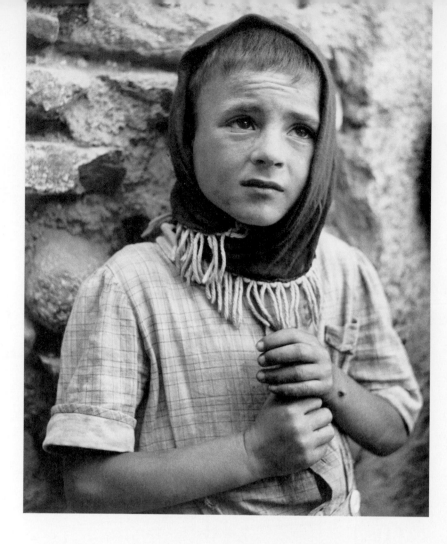

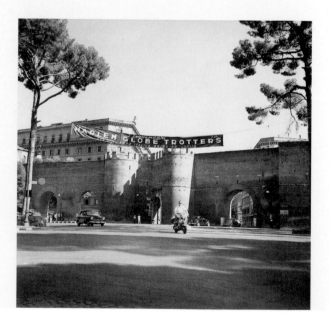

JERRY LEWIS

I shot all three of these pictures with a Rollieflex on a trip to Italy. As an entertainer I could not resist taking the shot of the Roman Coliseum and wondering what thoughts raced through the minds of those who were forced to entertain for such a bloodthirsty throng. Lining up this shot, I couldn't help wondering if I could have been able to make Caesar laugh.

Imagine my surprise when I started out to get my first look at the old Roman ruins my first morning in Rome, and the first thing to greet my wide eyes was the Harlem Globetrotter banner strung near the old Roman wall. It was too much.

The portrait of the boy tells a more complete story than any other I have ever taken. The suffering and the deprivation of the Italian peasant is apparent in the boy's face, yet in his eye is the spark of hope for a better life in the future.

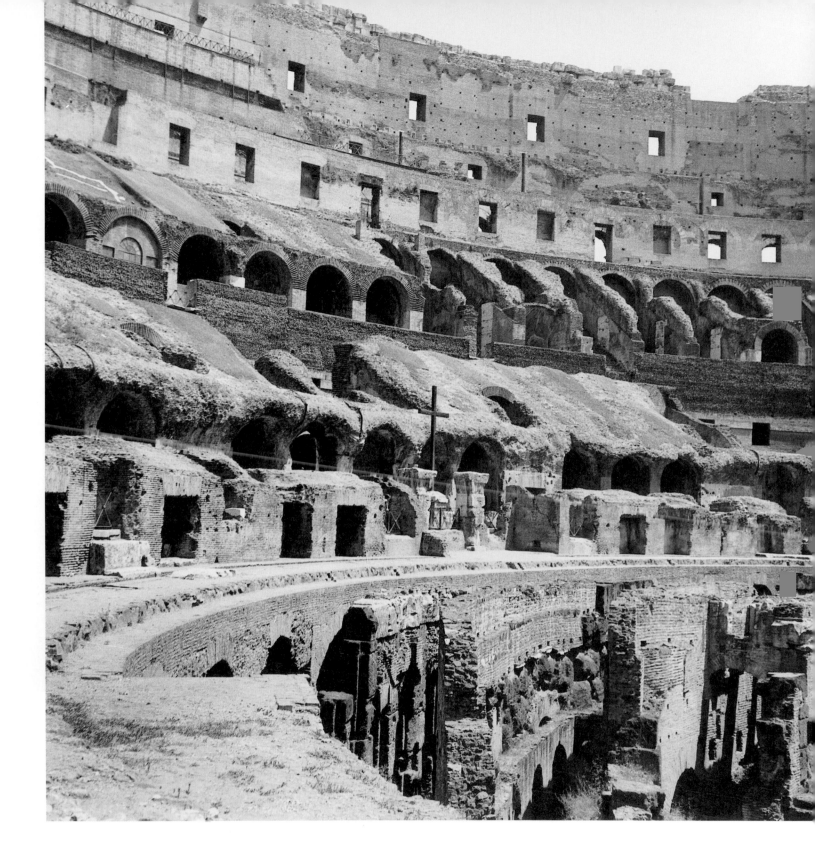

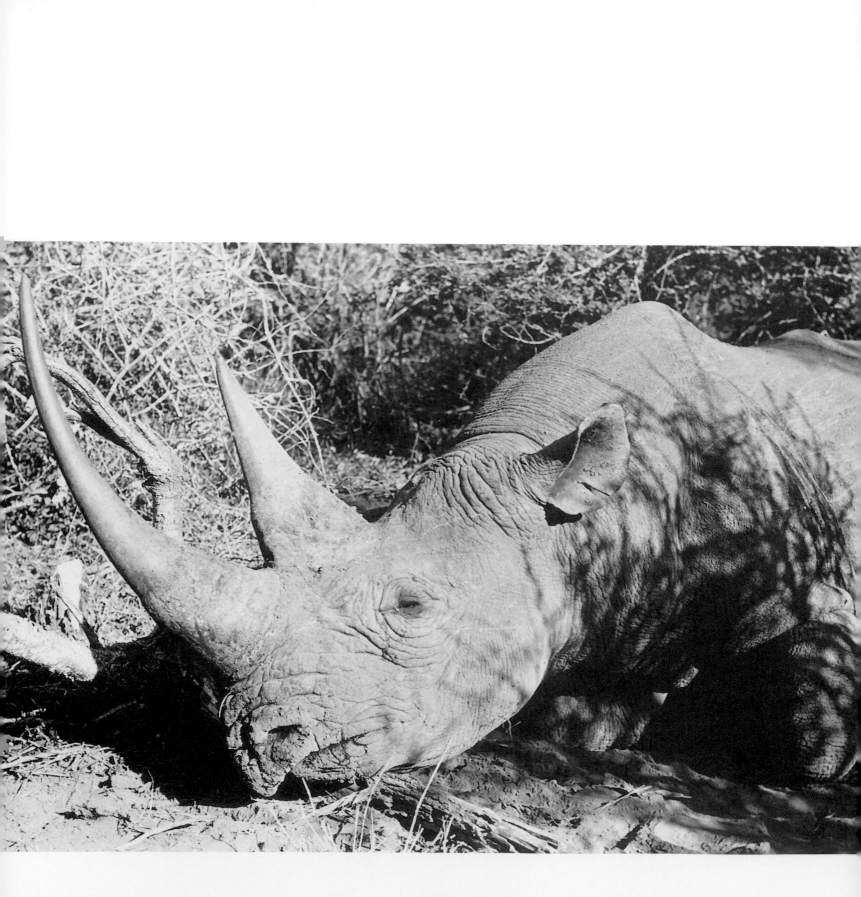

Napoleon said, "A look is worth a thousand reports." So it is with a picture. It brings back the evidence. And, of course, great evidence—that kind which you wish to show your family and friends. These pictures, all taken by me as a poor amateur with a Leica, prove my story.

Opposite is a close-up of 100 percent cantankerous meanness at rest, shot—gun- and camerawise—in Africa in November 1955. As an army man, a hunter, one who loves the outdoors and people, I find that a picture taken by myself provides immeasurable pleasure and satisfaction. The portrait is of Dr. Syngman Rhee at the age of 82.

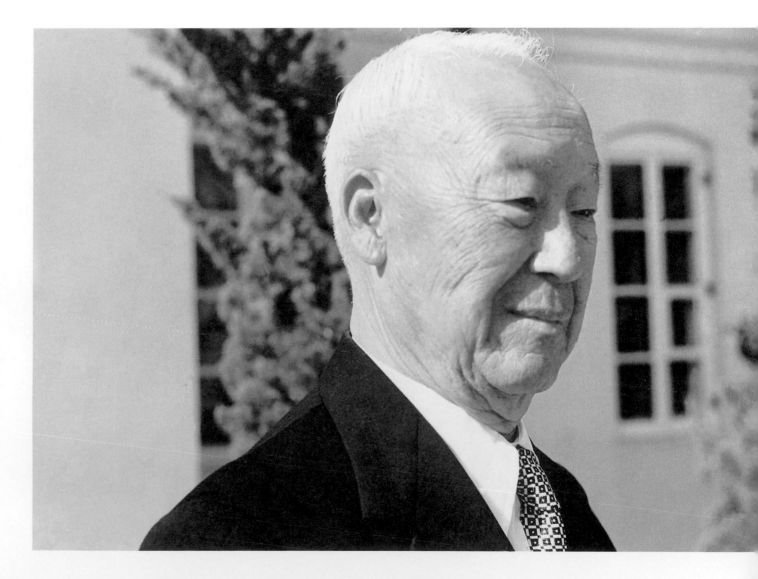

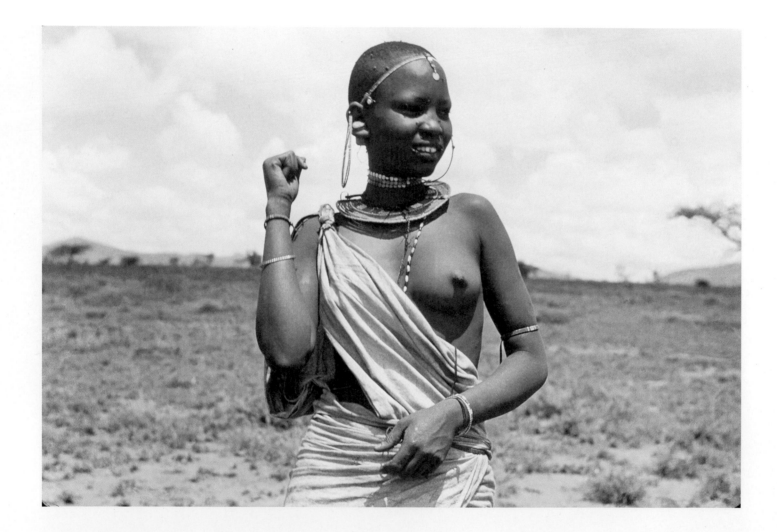

GENERAL JAMES A. VAN FLEET

Masai girl, age 16, for sale. Sold for four cows.

I must have clicked the shutter of my Leica by accident when I shot this picture in the bull-ring at Tijuana, Mexico. I think that is so because the other pictures I took that day were not in the same league as this one. I have been to only two bullfights in my life and have not become an aficionado. Actually, I am not a camera fiend either. Mostly I specialize in capturing facial expressions of my wife and baby. I must have about 8,000 of these—which I realize are of no interest to anyone but myself and my wife. We don't paste the pictures in albums, just keep them in a big box and like to get them out and look at them now and then.

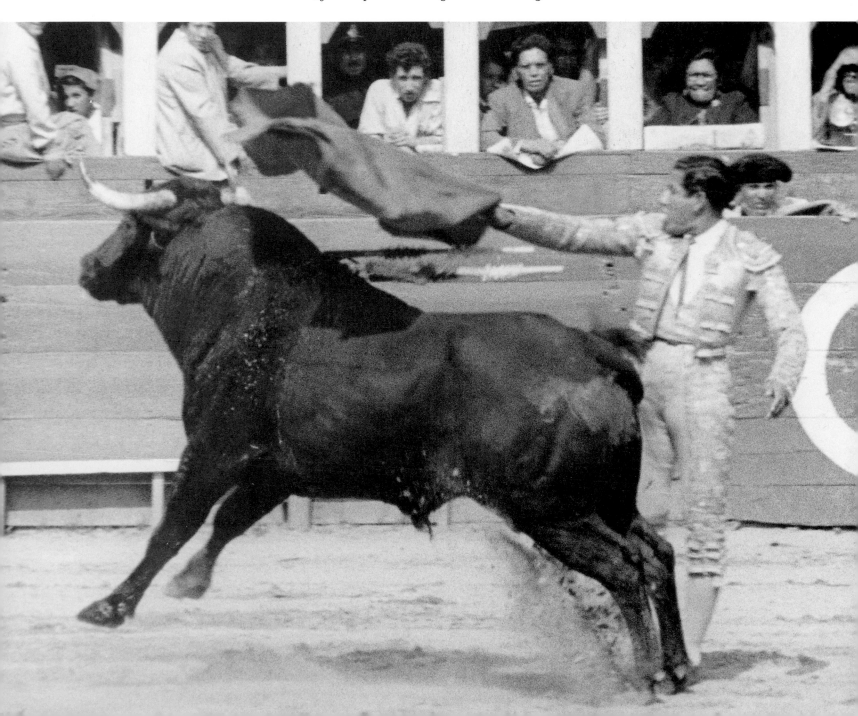

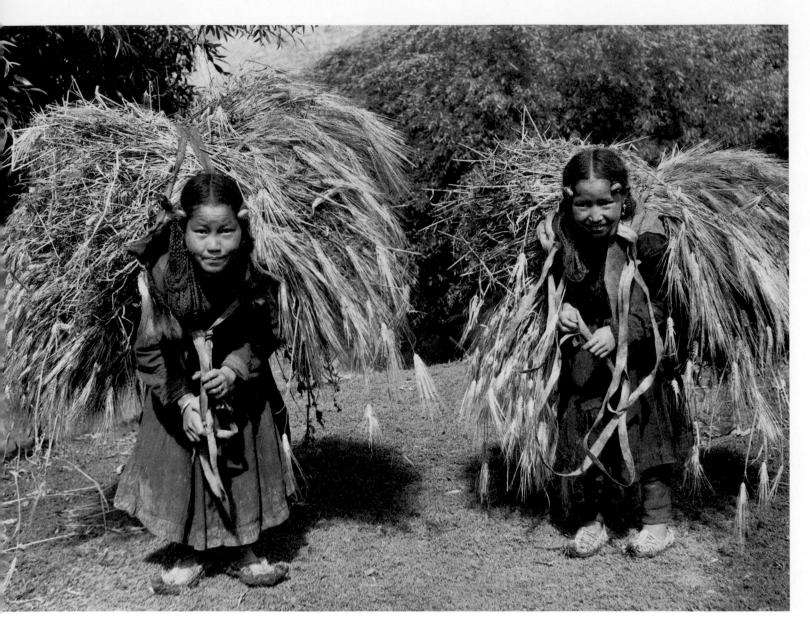

JUSTICE WILLIAM O. DOUGLAS

In the summer of 1951, I took a long trek on foot and by pack train over the Himalayas from Manali to Leh. In Lahul I took a picture that can touch anyone's heart as it did mine. These two little Lahuli girls are carrying wheat to the threshing floor. In Lahul the women carry the full burden of the house and the main burden of the fields. The men plow in the spring and help out with the harvest in the fall. The rest of the time they sit under a tree and watch the women and girls hoe, cultivate, and weed. And when the wheat or barley is cut, it is the women who carry it in baskets or slings on their backs to the threshing floor and winnow out the grain. Lahul is indeed a man's world.

I took the picture on the right with my M3 Leica, at the farmer's private market in Tashkent, Uzbekistan. Produce grown by farmers on their private tracts (which average about one acre) can be sold at any price the market will bring. And the proceeds from the sales are exempt from Russia's income tax.

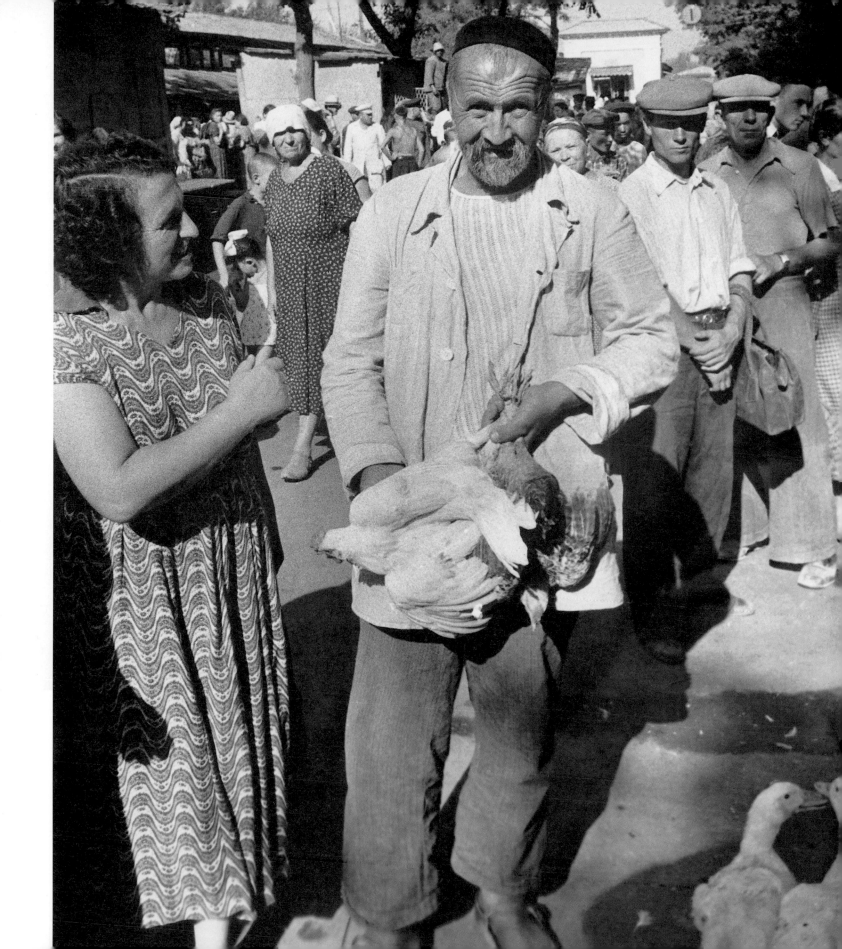

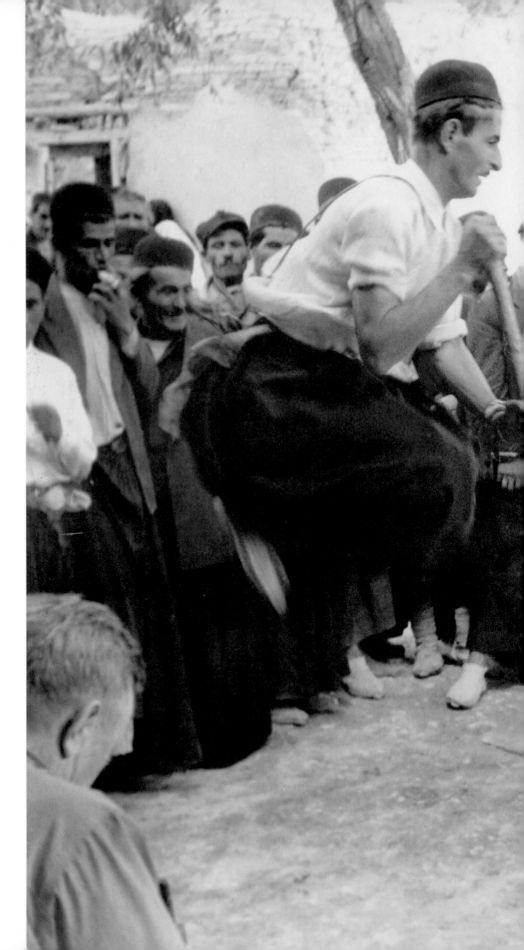

JUSTICE
WILLIAM O. DOUGLAS

When I first went to the Middle East in 1949, I took with me a Rollieflex and an Eastman movie camera. I made many mistakes and lost some good pictures. But I had enough good luck to encourage my efforts at "picture-taking." On five successive trips to Asia and on my various summer vacations on this continent, I have carried more and more equipment and have accumulated by now many thousands of pictures. With them I have been able to bring my American friends closer to a part of the world few know but which draws me back time and again.

The street scene demonstrates one of Russia's main problems, the lack of paved roads. I took this in Petropavlosk, Kazakhstan, where none of the streets were paved.

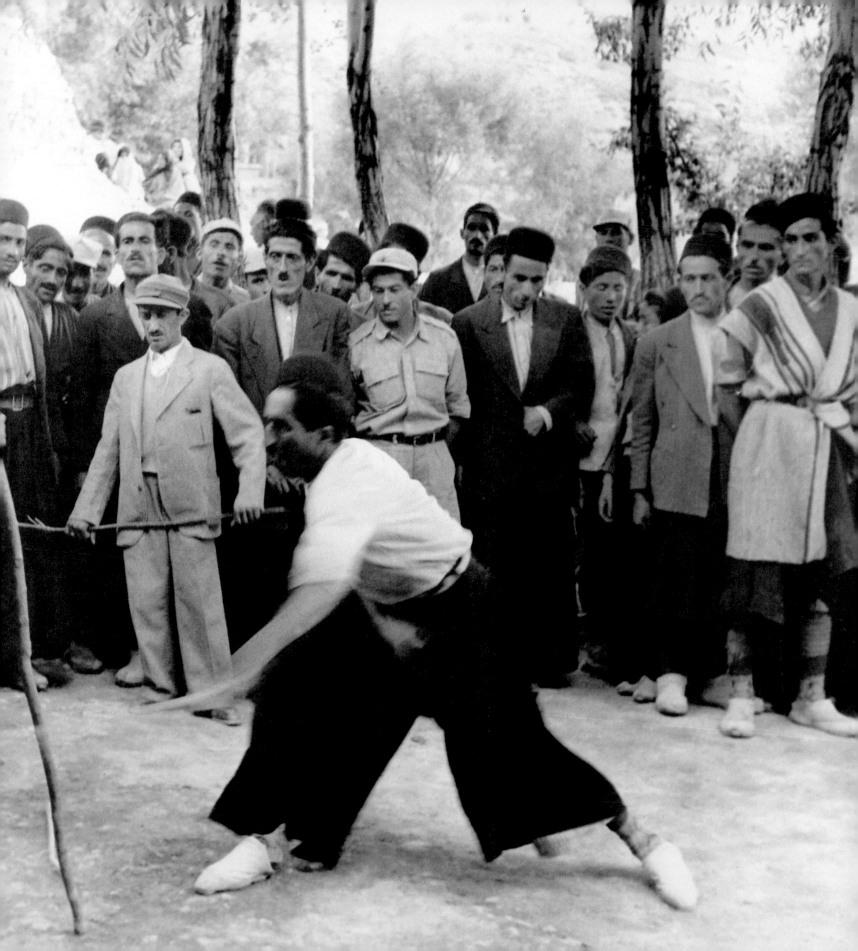

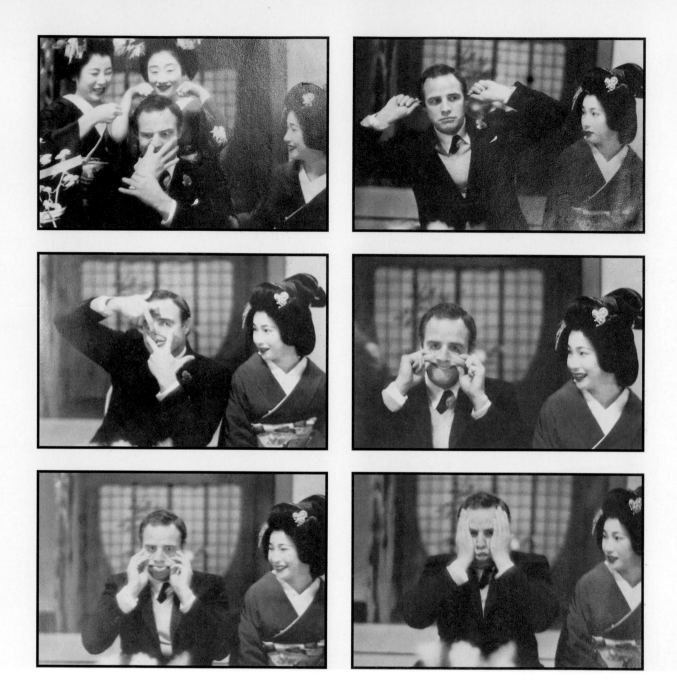

One evening, just before we started shooting *Sayonara* in Kyoto, Bill Goetz, the producer, gave a party for Marlon Brando in a hotel. The room was loaded with Geisha girls and Japanese starlets and actresses, and, of course, I had my Nikon. Marlon was excited about the start of the picture, and I asked him, "Give me a lot of shots, Marlon." To my delight, and certainly to the delight of the Geishas who took it all in, Marlon's response was wonderful and certainly shows him as few people have ever seen him.

I am an amateur, an avid amateur photographer, as far as the taking of pictures is concerned, but a professional in their use. These shots (above and on the next page) are examples of that. One day each year, Japanese in Kyoto perform this "Devil Dance" to keep the devils and other evil spirits from getting inside their temple. I photographed the actual ceremony as an amateur photographer but had a professional motive: I went to see the ceremony to see if I wanted to incorporate it in *Sayonara*. I also show many of my pho-

tographs to actors or art directors to illustrate a point or an idea. One reason I could make the switch from the stage to screen was because I was familiar with the requirements and the limits of the camera, the value of texture, of close-ups. Actually, I get so involved in shooting pictures, I can't relax. Last time I traveled around the world, I deliberately limited myself to one camera. The photograph of Mary Martin (page 169) was taken in Jamaica, after she returned from Great Britain, where she played Nellie Forbush in *South Pacific*.

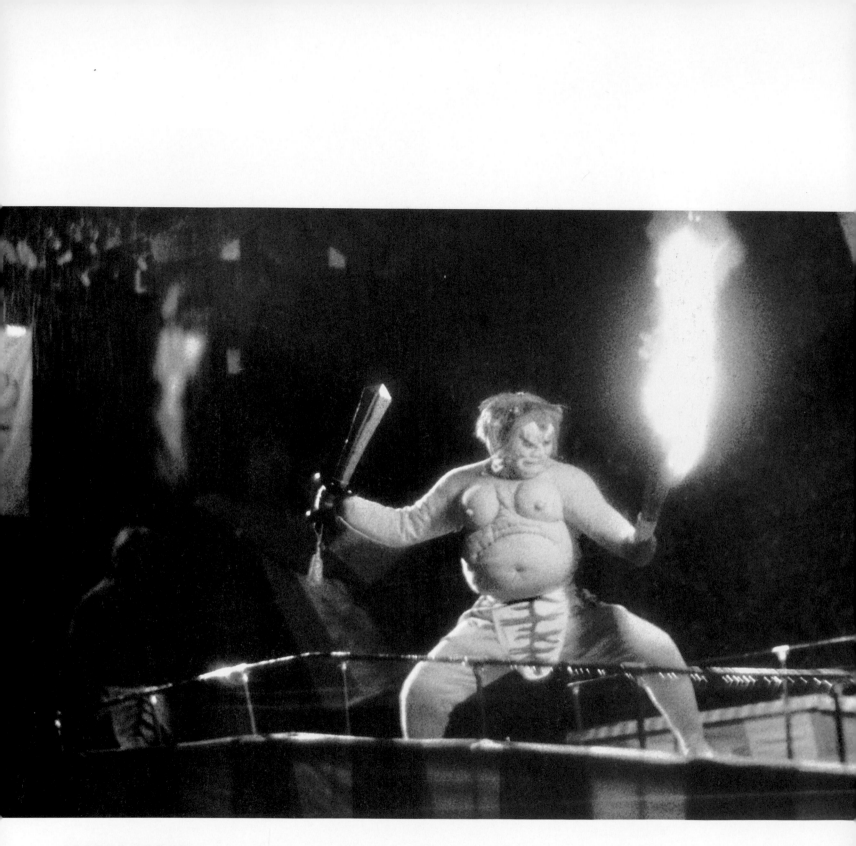

JOSHUA LOGAN

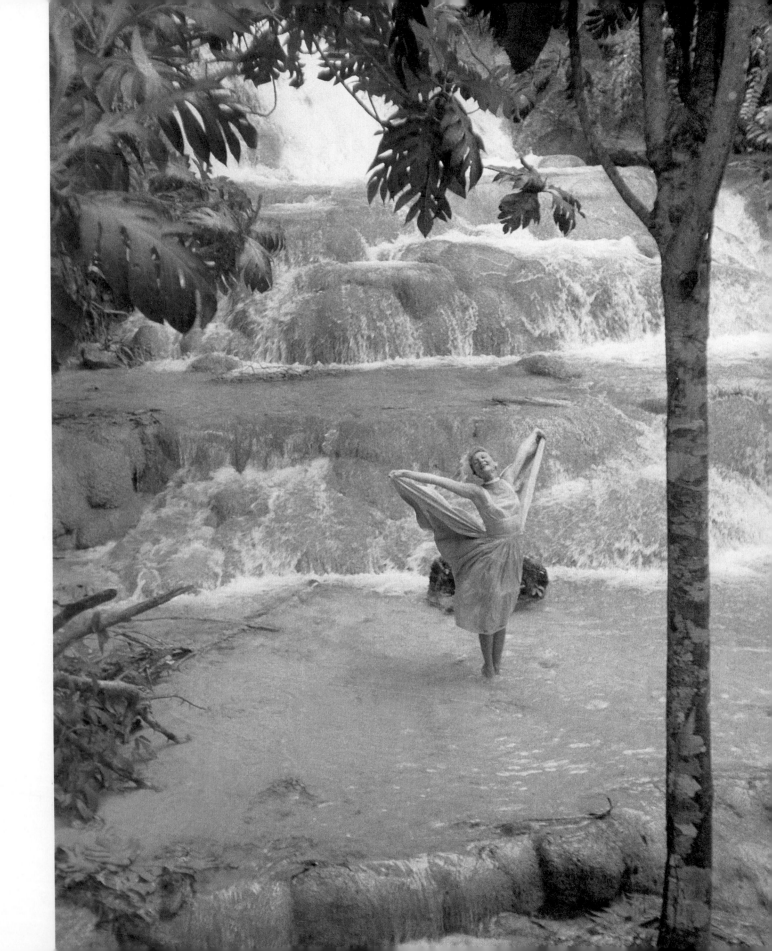

BURL IVES

I look for one thing in my own photographs: that is to recapture the moment of visual awareness that, in affecting me, has made me wish to preserve it. Esthetic value, such as composition, soft and hard tone qualities, and so forth, are not at any time my primary objective. I am not trying to be artistic, either, in the sense that an artist consciously weighs values, nor in the sense that an artist is one who wishes to communicate an experience to many people. I photograph for myself, perhaps to share once in awhile with friends and family.

In 1950, I bought a Leica with an F2 lens in Tripoli. The photographs on these pages were all taken with this camera. My favorite is the portrait of Thomas Hart Benton, the painter,

taken at his home in Kansas City. At the moment, he was commenting, with the penetration so peculiar to himself, on the book in his hand. Also he is a creature of dark and light, and to have found him for a moment exposed in full sunlight was worth capturing to print.

A few years ago, I made my first extended trip to Ireland. On a rocky road in Connemara, this little towhead stopped traffic more effectively than a herd of sheep. She wouldn't smile at us nor be cajoled to move. I finally got out of the car and wooed her over to the side of the road and gave her some candy. She clutched her precious booty and disappeared behind a stone fence. We proceeded on our way.

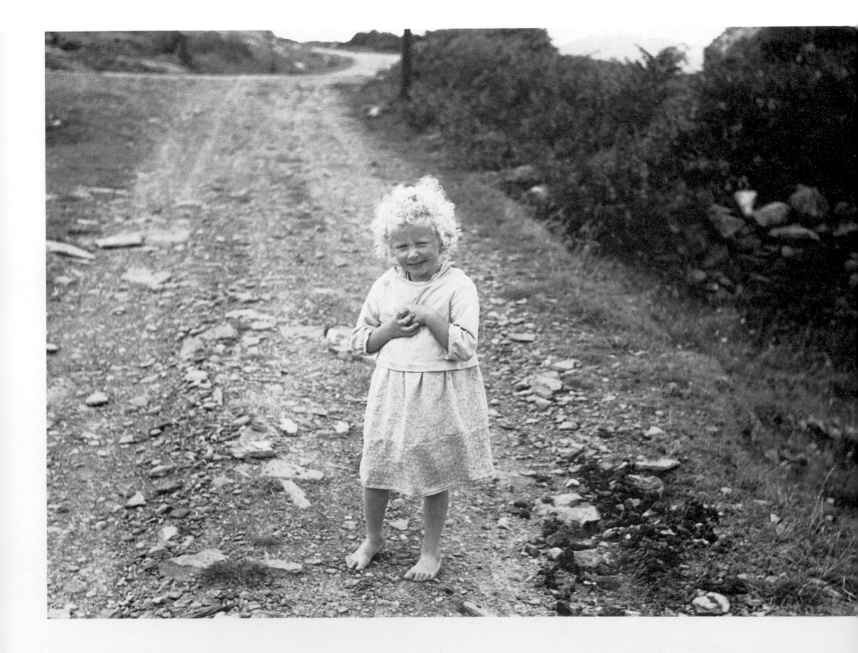

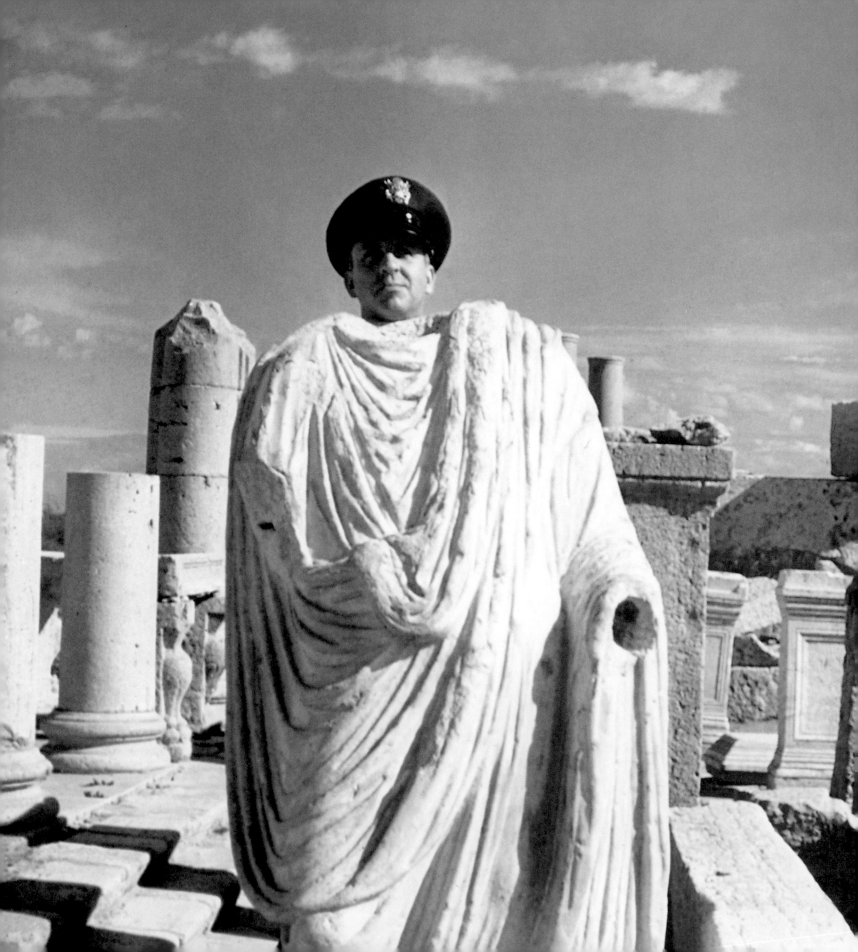

BURL IVES

I saw Leptis Magna for the first time in 1950 when I was overseas on a concert tour for MAATS. The grandeur and effort of the dead past, its architectural beauty and overwhelming dignity, were so impressive and oppressive a place to see that my companion was moved to break the mood by popping his head up over the toga stone body of some ancient dignitary. Catching him in this irreverent action met a need I also felt at the moment. This brings back the quality of that ancient city in Tripoli, more than any other of the photographs I have of that experience.

And so it goes, almost every photograph which I feel has been successful conveys to me the poignancy of its own moment.

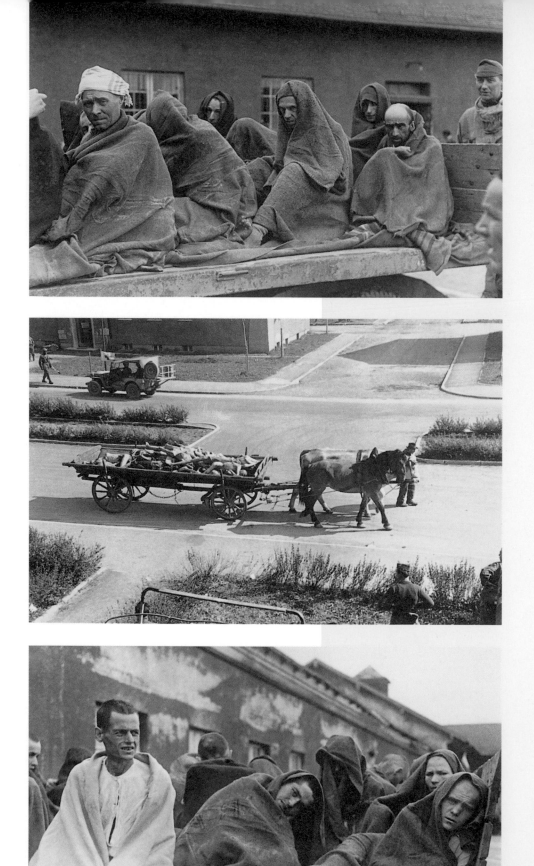

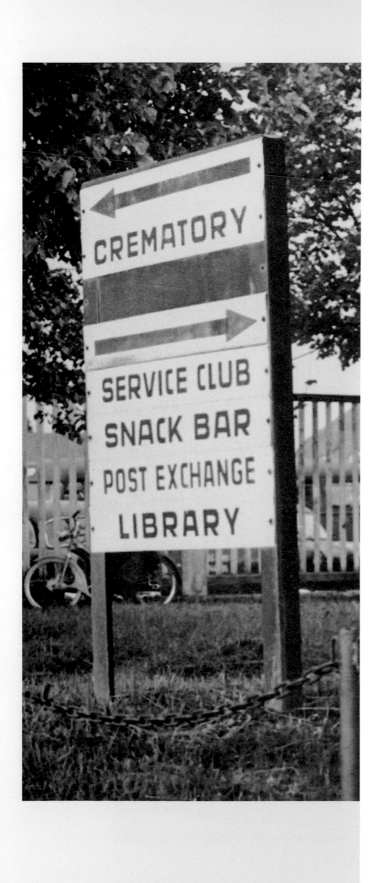

In World War II, I was the commanding officer of Specou Shaef Combat and Observation Cameras, assigned by General Eisenhower's Supreme Headquarters to various army corps or divisions in the field. We covered most all of the activities of the campaign on the Continent—the June 6 landings; Normandy buildup, breakthrough, and development; Paris liberation; the advance to the Siegfried Line; the Winter of 1944–45 at Achen, Hertgen Forest, and the Ardennes; then the collapsing German resistance; the USA–Russian linkup at Torgan, across the Elbe River; and Nordhausen concentration camp where they made the V1 and V2s. Then, toward the end, came orders to get down to the 45th Division outside Dachau during the last days of April. I have no short comment about this. The pictures taken there by my unit—and those taken by me personally—are never looked at by anyone anymore. No one is that curious. The photographs of those who survived, and those who didn't, like most everyone's recollection of this great misfortune, are seldom referred to consciously, although the recollections, I am sure, have strong subconscious recall.

At that time, the pitiful conditions of the survivors in the concentration camps made the war itself and its misfortunes seem worthwhile. Because these liberations were so necessary, it seemed to show a need for war to accomplish this. Naively, we thought this had brought about the end of concentration camp misery. Would that it were so.

Last year, while revisiting the Continent to do research for my production of *The Diary of Anne Frank*, I returned to the place called Dachau. I held my breath as I approached it. Dachau had grown like Burbank, California. It was bustling with activity. We finally found the old SS barracks. The Nazi eagle was still above the archway. Beneath it a U.S. Army battalion was standing retreat. To drive away, we followed the arrows, and I swallowed hard when I saw the sign that now pointed toward the Snack Bar and the Crematorium. It didn't seem that anyone had learned very much from all this great misfortune.

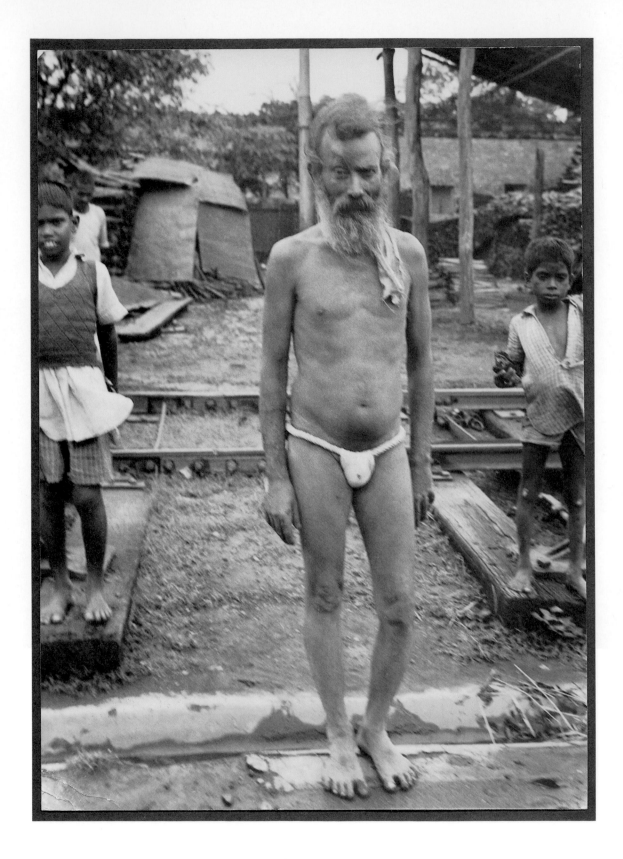

Despite his costume, the tall, thin gentleman at the left has nothing to do with my business. He is a Sadu, a self-appointed Holy man who lives a life of penance. The loincloth is his wardrobe and he wears it—and nothing but it—summer and winter. It was cold the day I saw him in Calcutta. I was wearing a warm coat and it was a shock to see him walking around with no clothes on. He was most obliging; came over to the car so I could take his picture and he would not accept a tip.

To shoot the self-portrait of myself getting a drink at the Tivoli Gardens in Rome, I set the camera on a tripod, focused on the fountain, tripped the self-timer, and then got into position. I made several pictures of myself this way.

I shot hundreds of pictures on this trip: I had gone down to play Australia and came home on the bias. When it comes to photography I am a magpie—I collect everything—movies, stills, stereos. It is difficult to say why I take pictures, but I have been taking them since I was a child starting with a two-dollar Brownie. I shoot pictures for the same reason some women buy diamonds and furs.

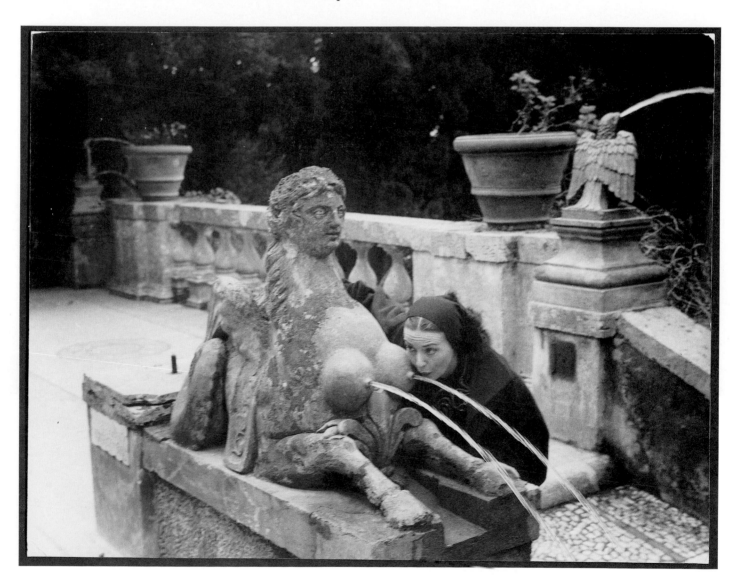

The picture below is of my sister, June Havoc, buying a rug in Marrakech.

The heavily populated waterway on the following page is called a klang, and the entire native quarter of Bangkok lives on a network of them. The homes and stores are either floating or built on stilts and, of course, all travel is by boat. Most of these people spend their whole lives on these klangs, never set foot on solid ground. They use the river water for all purposes—drinking, bathing, for everything. As we rode around I saw a

dead horse and dead dog floating along. But they seemed to be as healthy a group as I've seen. For obvious reasons, tourists never eat any of the food cooked on the klangs, but I came upon a restaurant where everything smelled so good I pitched right in and ate a complete meal. It didn't bother me a bit. That's what show business has done for me; spending my life in vaudeville conditioned me for anything.

On the following spread (180-181) is a self-portrait I took as I was buying stamps in Rangoon.

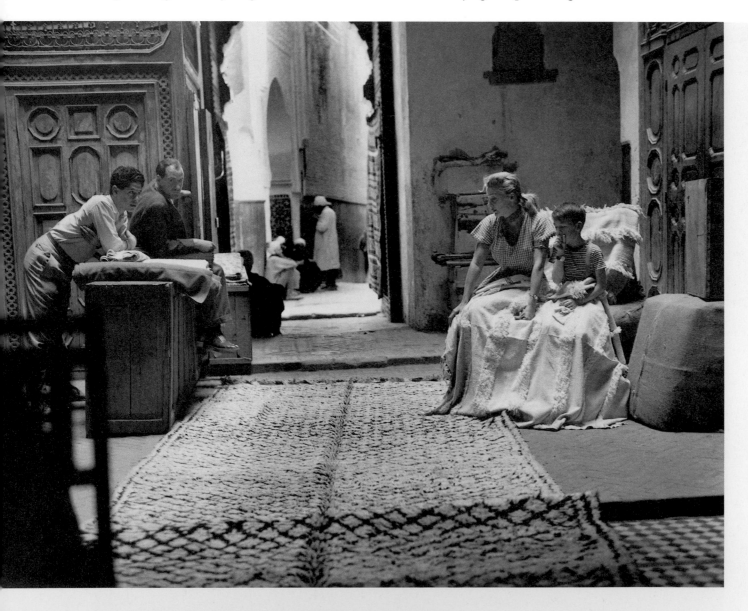

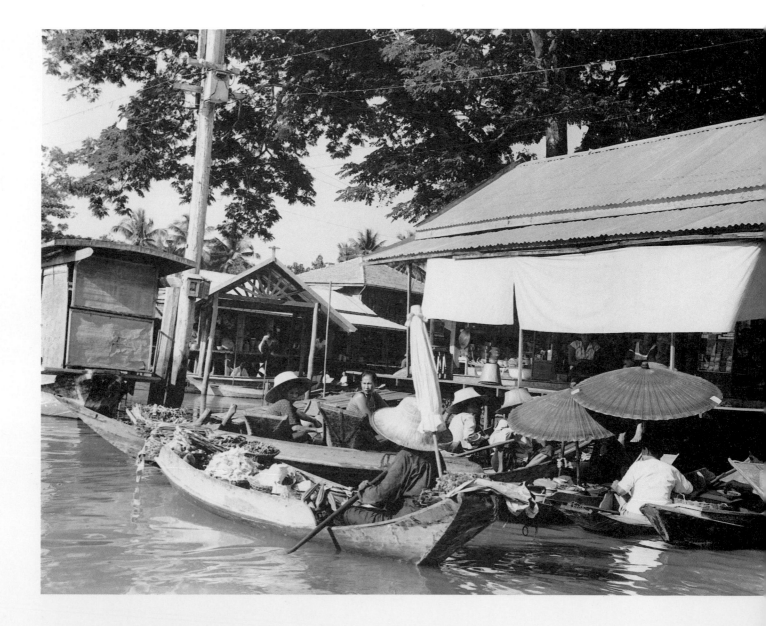

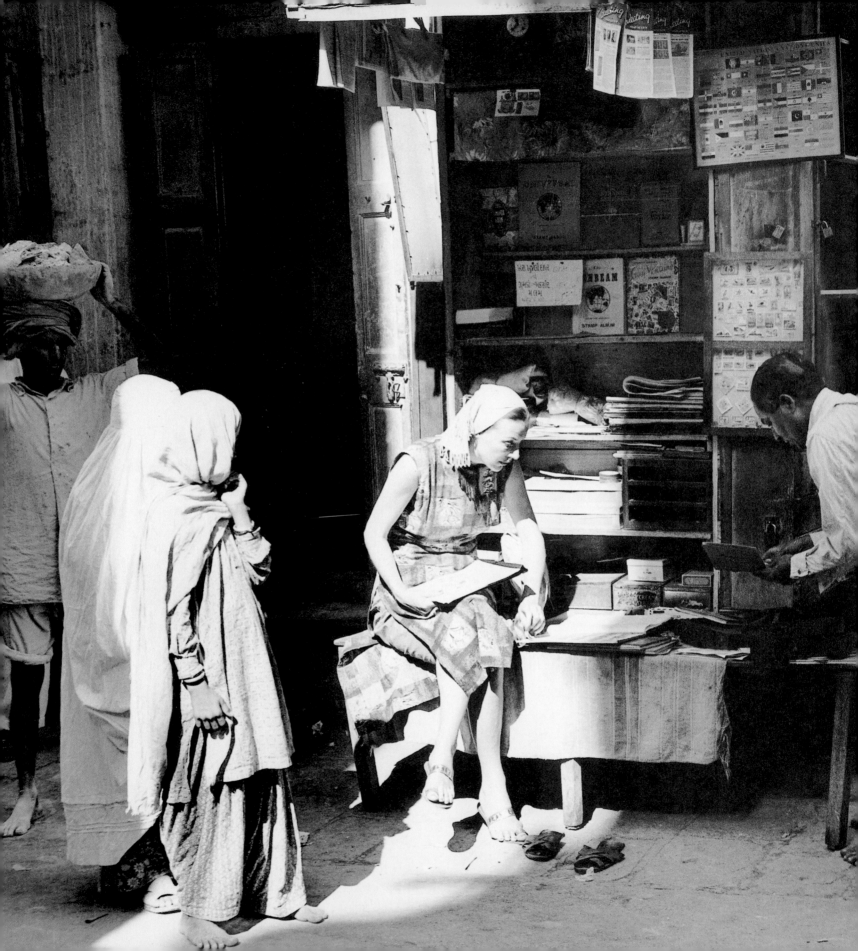

GYPSY ROSE LEE

JAMES STEWART

I'm really proud of this picture. I was riding in a car
in Marrakech in Morocco and saw these people walking
along, saw that shadow of the bedspring on the
ground and was fascinated by the story being told
right there. I grabbed my camera and ran out and
grabbed the shot. There was no time for fidgeting and
focusing. I just ran out and bang, made it. I shot this
using my Leica, which I carry on all of my trips. I
don't shoot pictures of places just because I am there.
There must be a special reason, some personal con-
nection. I shoot in black and white only, have all my
shots enlarged to 8 x 10, mounted back to back, and
bound into books. We keep these books on shelves in
our living room and I love to browse through them,
retracing the steps of each trip, enjoying again the fun
of each episode.

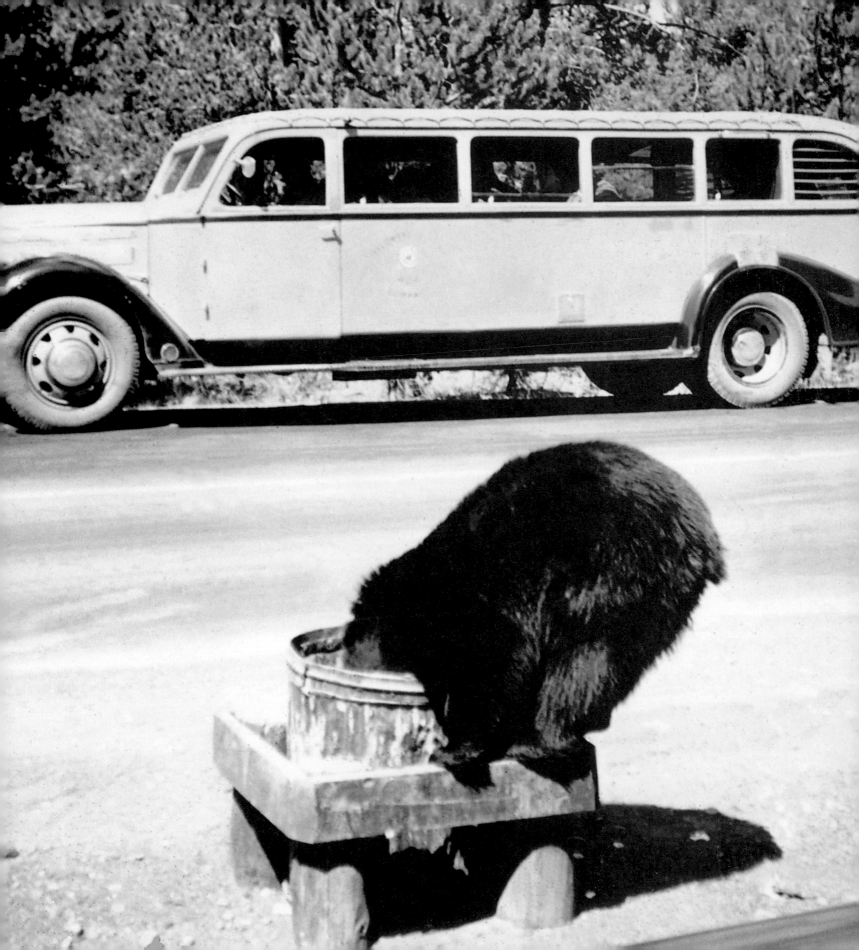

PATRICE MUNSEL

My husband and I were driving east on a recent trip and we stopped to visit Yellowstone National Park on the way. As we were walking along, we spotted this little bear scavenging for food. We thought the sight of him with his head buried deep in the garbage pail was one of the funniest things we'd ever seen. I had time to make just one shot with my Stereo-Realist. I love the picture for its amusement value. We laugh at that little bear every time we look at the picture, which makes it just about priceless.

ACKNOWLEDGMENTS

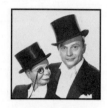

EDGAR BERGEN (1903–1978) noted ventriloquist; best known for performing with dummy Charlie McCarthy in radio, television, and films, topping off his career with a final appearance in *The Muppet Movie*.

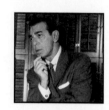

EDDIE CANTOR (1892–1964) singer and comedian best known for his successful radio show.

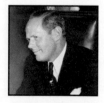

SHERMAN BILLINGSLEY (1900–1966) realtor; owner of The Stork Club, a popular high-society nightclub and restaurant in Manhattan.

ROSEMARY CLOONEY (b.1928) popular jazz and pop singer noted for her hit "Come-on-a-My-House"; costarred in *White Christmas* (1954); in 1998 released a CD entitled *70*.

ERNEST BORGNINE (b.1917) screen actor best known for his Academy Award–winning performance in *Marty* (1955), as well as roles in such films as *From Here to Eternity* (1953) and *The Poseidon Adventure* (1972).

NAT "KING" COLE (1917–1965) recording artist, musician; first African American to reach mainstream acceptance as a popular singer with such hits as "The Christmas Song" and "Unforgettable."

GENERAL OMAR N. BRADLEY (1893–1981) General of the Army; commanded the U.S. 12th Army Group in Europe during World War II; first Chairman of the Joint Chiefs of Staff from August 1949 until his retirement from the military service in 1953.

GARY COOPER (1901–1961) screen actor best known for his Academy Award–winning work in such films as *Sergeant York* (1941) and *High Noon* (1952); other starring vehicles include *Mr. Deeds Goes to Town* (1936), *The Pride of the Yankees* (1942), and *Love in the Afternoon* (1957).

BING CROSBY (1904–1977) star of radio, records, films, and television; Academy Award winner for *Going My Way* (1944); costarred with Bob Hope and Dorothy Lamour in several *Road* movies; earned 23 gold records in his lifetime.

JUSTICE WILLIAM O. DOUGLAS (1898–1980) Supreme Court justice for more than 36 years (1939–1975); staunch defender of civil liberties; author of *An Almanac of Liberty* (1954) and *Democracy's Manifesto* (1962).

TONY CURTIS (b.1925) screen actor best known for his roles in *Some Like It Hot* (1959), *The Vikings* (1958), *Spartacus* (1960), and *The Boston Strangler* (1968).

DWIGHT D. EISENHOWER (1890–1969) 34th president of the United States (1953–1961); supreme commander of Western Allied forces during World War II.

SAMMY DAVIS JR. (1925–1990) multitalented star of stage and screen; films include *Ocean's 11* (1960) and *Robin and the 7 Hoods* (1964) with Frank Sinatra and Dean Martin, and *Sweet Charity* (1969); song "Candy Man" topped the charts in 1972.

JOSE FERRER (1912–1992) stage and screen actor; Academy Award winner for *Cyrano de Bergerac* (1950); also starred in *Moulin Rouge* (1953) and *Lawrence of Arabia* (1962).

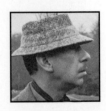

GENERAL WILLIAM F. DEAN (1899–1981) hero of the Korean War; author of best-seller *General Dean's Story*; the last military governor of Korea before it became a republic.

BETTY FURNESS (1916–1994) screen actress and consumer advocate; best known as television spokesperson for Westinghouse.

KIRK DOUGLAS (b.1916) screen actor, producer, writer; appeared in over 80 films including *Lust for Life* (1956), *Spartacus* (1960), *Seven Days in May* (1964), and *Song for David* (1996).

DAVE GARROWAY (1913–1982) radio announcer, whose popular jazz radio show led to *Garroway at Large*, an early television variety show; chosen by NBC in 1952 to become the first host of *Today*.

 BARRY GOLDWATER (1909–1998) Arizona senator; Republican candidate for president of the United States (1964); served as chairman of the Senate's Intelligence Committee from 1981 to 1987.

 CARY GRANT (1904–1986) screen actor; notable films include *Bringing Up Baby* (1938), *His Girl Friday* (1940), *The Philadelphia Story* (1941), *North by Northwest* (1959), and *Charade* (1963).

 GENERAL ALFRED GRUNTHER (1899–1983) U.S. general during World War II; NATO's Supreme Allied Commander in Europe.

 HELEN HAYES (1900–1993) stage and screen actress often referred to as the first lady of the American theater; received an Academy Award for her performance in *The Sin of Madelon Claudet* (1931), her debut film, and for her role in *Airport* (1970).

 LELAND HAYWARD (1902–1971) noted stage and screen producer and talent agent; produced *Mister Roberts* (1955) and *The Old Man and the Sea* (1958).

 ALFRED HITCHCOCK (1899–1980) director whose films include the Academy Award– winning *Rebecca* (1940), as well as *Strangers on a Train* (1951), *Rear Window* (1954), *North by Northwest* (1959), *Psycho* (1960), and *The Birds* (1963).

 WILLIAM HOLDEN (1918–1981) actor; Academy Award winner for *Stalag 17* (1953); featured in such films as *Sunset Boulevard* (1950), *Born Yesterday* (1950), *The Bridge on the River Kwai* (1957), and *The Wild Bunch* (1969).

 BURL IVES (1909–1995) actor and folk singer; Academy Award winner for *The Big Country* (1958); best known as Big Daddy in *Cat on a Hot Tin Roof* (1958).

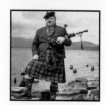 **BOBBY JONES (1902–1971)** sporting legend of the 1920s and 1930s; only golfer to win the Grand Slam, the four major golf tournaments of the era.

 DANNY KAYE (1913–1987) actor, comedian, dancer, singer; appeared in many films and the Emmy Award– and Peabody Award– winning *The Danny Kaye Show* (1963–1967).

 ELIA KAZAN (b.1909) Turkish-born director of stage and screen; Academy Awards for *Gentleman's Agreement* (1947) and *On the Waterfront* (1954); also directed *A Streetcar Named Desire* (1951), *East of Eden* (1955), and *Splendor in the Grass* (1961).

 ESTES KEFAUVER (1903–1963) U.S. sena- tor and representative from Tennessee; directed highly publicized investigation into organized crime.

GRACE KELLY (PRINCESS GRACE OF MONACO) (1929–1982) screen actress; received an Academy Award for her role in *The Country Girl* (1954); other films: *High Noon* (1952), *To Catch a Thief* (1955), *High Society* (1956).

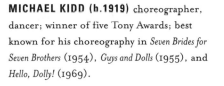

JERRY LEWIS (b.1926) actor, director, producer, humanitarian; teamed with Dean Martin; films include *The Nutty Professor* (1963); Broadway star in the 1990s in *Damn Yankees*.

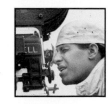

MICHAEL KIDD (b.1919) choreographer, dancer; winner of five Tony Awards; best known for his choreography in *Seven Brides for Seven Brothers* (1954), *Guys and Dolls* (1955), and *Hello, Dolly!* (1969).

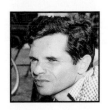

LIBERACE (1919–1987) pianist and entertainer; legendary star of Las Vegas; famous for his trademark candelabra.

BURT LANCASTER (1913–1994) actor and producer; Academy Award winner for title role in *Elmer Gantry* (1960); also noted for *From Here to Eternity* (1953), *Birdman of Alcatraz* (1962), and *The Swimmer* (1968).

LAWSON LITTLE (1910–1968) U.S. golfer; winner of the 1940 U.S. Open; among the first amateurs to turn professional.

ELSA LANCHESTER (1902–86) screen actress; best known for her role as *The Bride of Frankenstein* (1935).

HAROLD LLOYD (1894–1971) legendary star of silent screen; featured in a series of groundbreaking comedies.

GYPSY ROSE LEE (1914–1970) writer, actress, stripper; her autobiography *Gypsy* became a smash Broadway musical and film.

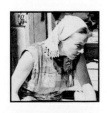

JOSHUA LOGAN (1908–1988) stage and screen director, playwright; films include *Picnic* and *Bus Stop* (1956), *South Pacific* (1958), and *Camelot* (1967).

JANET LEIGH (b.1927) actress noted for roles in *Touch of Evil* (1958), *Psycho* (1960), and *Bye Bye Birdie* (1963); author of *There Really Was a Hollywood*, *House of Destiny*, and, with Christopher Nickens, *Psycho: Behind the Scenes of the Classic Thriller*.

CLARE BOOTHE LUCE (1903–1987) wrote play *The Women* (1936); served in the U.S. House of Representatives as a Republican from Connecticut from 1943 to 1947; ambassador to Italy (1953–1956); married to magazine publisher Henry Luce.

 ROUBEN MAMOULIAN (1898–1987) film director best known for *Dr. Jekyll and Mr. Hyde* (1932), *Queen Christina* (1933), *Golden Boy* (1939), and *Silk Stockings* (1957).

 PATRICE MUNSEL (b.1925) soprano opera star, appeared at the Metropolitan Opera and in operettas and musical comedy.

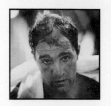 **ROCKY MARCIANO (1923–1969)** legendary boxer; won 37 fights by knockouts; defended his world heavyweight championship title six times.

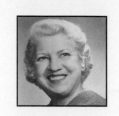 **JACQUELINE COCHRAN ODLUM (1912–1980)** American businesswoman and pioneer airplane pilot; the first civilian woman to receive the Distinguished Service Medal; elected to the Aviation Hall of Fame in 1971.

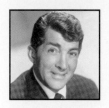 **DEAN MARTIN (1917–1995)** singer and actor; worked in clubs, radio, television, and film; comedy partner of Jerry Lewis; films include *The Young Lions* (1958), *Some Came Running* (1959), *Ocean's 11* (1960), and *Airport* (1970).

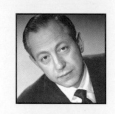 **WILLIAM S. PALEY (1901–1990)** president and founder of CBS; art collector; trustee of the Museum of Modern Art.

 RAYMOND MASSEY (1896–1983) actor best known for his role as Abraham Lincoln in *Abe Lincoln in Illinois* (1940); also played Dr. Gillespie in TV's early '60s series *Dr. Kildare*.

 GREGORY PECK (b.1916) screen actor; received an Academy Award for *To Kill a Mockingbird* (1962). Other notable films: *Gentleman's Agreement* (1947), *Twelve O'Clock High* (1950), *Roman Holiday* (1953), *On the Beach* (1959), *The Omen* (1976).

 YEHUDI MENUHIN (b.1916) violinist and conductor; made his public debut with the Mendelsson concerto at age seven; founded the Menuhin School of Music.

 TYRONE POWER (1914–1958) actor best known for his romantic leads in *The Razor's Edge* (1946), *Nightmare Alley* (1947), and *The Sun Also Rises* (1957).

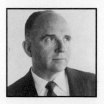 **JAMES A. MICHENER (1907–1997)** author; Pulitzer Prize winner for *Tales of the South Pacific* (1948); other books include *Hawaii* (1959), *The Source* (1965), *Centennial* (1974), and *Space* (1982).

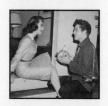 **ELVIS PRESLEY (1935–1977)** The King of Rock and Roll, known for such chart-topping hits as "Hound Dog," "Blue Suede Shoes," "Jailhouse Rock," "Heartbreak Hotel," and "Suspicious Minds"; also starred in 33 films; his Memphis home Graceland is a museum.

DEBBIE REYNOLDS (b.1932) stage and screen actress, featured in such films as *Singin' in the Rain* (1952), *The Tender Trap* (1955), *The Unsinkable Molly Brown* (1964), and *Mother* (1996).

DINAH SHORE (1917–1994) singer and actress; starred in many films and a long-running Emmy-winning television show.

JEROME ROBBINS (1918–1998) choreographer and dancer for stage and screen; Academy Award winner for codirecting *West Side Story* (1961); multiple Tony Award winner for his work on Broadway; one-time joint ballet master of the New York City Ballet.

FRANK SINATRA (1915–1998) singer, actor, director, humanitarian; dubbed "The Entertainer of the Century"; multiple Grammy winner; Academy Award winner for *From Here to Eternity* (1953); other films include *The Man With the Golden Arm* (1955), *The Manchurian Candidate* (1962), *Von Ryan's Express* (1965).

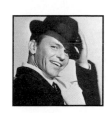

GINGER ROGERS (1911–1995) stage and screen actress and dancer; Academy Award winner for *Kitty Foyle* (1940); also noted for her roles in *Flying Down to Rio* (1933), *Shall We Dance* (1937), *The Major and the Minor* (1942), and *Lady in the Dark* (1944).

RED SKELTON (1913–1997) actor; television superstar best known for such characters as Freddy the Freeloader and Clem Kadiddlehopper.

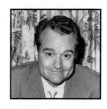

ELEANOR ROOSEVELT (1884–1962) wife of President Franklin Roosevelt; a powerful voice on behalf of civil rights for women and blacks, wrote a daily newspaper column entitled "My Day."

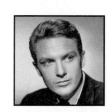

ROBERT STACK (b.1919) actor; films include *The High and the Mighty* (1954) and *Written on the Wind* (1957); played Eliot Ness in the long-running TV series *The Untouchables*.

ROSALIND RUSSELL (1912–1976) actress and comedienne; notable roles include *The Women* (1939), *His Girl Friday* (1940), *Auntie Mame* (1958), and *Gypsy* (1962).

GEORGE STEVENS (1905–1975) Academy Award–winning director for *A Place in the Sun* (1951) and *Giant* (1956); other notable films include *Shane* (1953) and *The Diary of Anne Frank* (1959).

SENATOR LEVERETT SALTONSTALL (1892–1979) U.S. Republican politician; governor of Massachusetts; chairman of the Senate Armed Services Committee.

ADLAI E. STEVENSON (1900–1965) U.S. Democratic statesman; governor of Illinois; twice nominated as his party's presidential candidate; appointed U.S. ambassador to the United Nations by President John F. Kennedy in 1961.

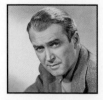

JAMES STEWART (1908–1997) actor best known for *It's a Wonderful Life* (1946), Academy Award winner for his role in *The Philadelphia Story* (1940); classic films include *Mr. Smith Goes to Washington* (1939), *Harvey* (1950), *Rear Window* (1954), *The Spirit of St. Louis* (1957), *Vertigo* (1958), and *Shenandoah* (1965).

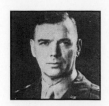

JAMES ALWARD VAN FLEET (1892–1992) U.S. general; led a battalion in World War I; commanded a regiment in World War II as well as the U.S. 8th Army in the Korean War; promoted to four-star general.

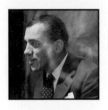

ADMIRAL LEWIS STRAUSS (1896–1974) naval officer, scientist; commodore during World War II; named rear admiral by President Truman in 1945.

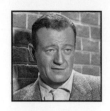

JOHN WAYNE (1907–1979) actor known as "Duke"; Academy Award winner for *True Grit* (1969); noted for his roles in *Stagecoach* (1939), *Fort Apache* (1948), *The Quiet Man* (1952), *The Searchers* (1956), and *The Green Berets* (1969).

ED SULLIVAN (1901–1974) TV personality, columnist; hosted *The Ed Sullivan Show*, one of television's greatest variety shows, from 1948 to 1971.

ESTHER WILLIAMS (b.1923) champion swimmer turned actress featured in such films as *Bathing Beauty* (1944) and *Neptune's Daughter* (1949).

HARRY S. TRUMAN (1884–1972) 33rd president of the United States (1945–1953).

TED WILLIAMS (b.1918) outfielder with Boston Red Sox; batted a phenomenal .406 in 1941; led the league in home runs four times.

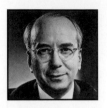

GLORIA VANDERBILT (b.1924) heiress to the Vanderbilt fortune; multi-talented painter, writer, sculptor, and fashion designer.